MPHIGOREY TOO

AMPHIGOREY

Edward Gorey

TOO

A Perigee Book

A PERIGEE BOOK
Published by the Penguin Group
Penguin Group (USA) Inc.
375 Hudson Street, New York, New York 10014, USA
Penguin Group (Canada), 90 Eglinton Avenue East, Suite 700, Toronto, Ontario M4P 2Y3, Canada
(a division of Pearson Penguin Canada Inc.)
Penguin Books Ltd., 80 Strand, London WC2R 0RL, England
Penguin Group Ireland, 25 St. Stephen's Green, Dublin 2, Ireland (a division of Penguin Books Ltd.)
Penguin Group (Australia), 250 Camberwell Road, Camberwell, Victoria 3124, Australia
(a division of Pearson Australia Group Pty. Ltd.)
Penguin Books India Pvt. Ltd., 11 Community Centre, Panchsheel Park, New Delhi—110 017, India
Penguin Group (NZ), 67 Apollo Drive, Rosedale, North Shore 0632, New Zealand
(a division of Pearson New Zealand Ltd.)
Penguin Books (South Africa) (Pty.) Ltd., 24 Sturdee Avenue, Rosebank, Johannesburg 2196,
South Africa

Penguin Books Ltd., Registered Offices: 80 Strand, London WC2R 0RL, England

While the author has made every effort to provide accurate telephone numbers and Internet addresses
at the time of publication, neither the publisher nor the author assumes any responsibility for errors, or
for changes that occur after publication. Further, the publisher does not have any control over and does
not assume any responsibility for author or third-party websites or their content.

AMPHIGOREY TOO

The works in the present volume were first published as indicated:
The Unstrung Harp, 1953, *The Listing Attic*, 1954, Duell, Sloan and Peaire-Little Brown;
The Doubtful Guest, 1957, *The Object-Lesson*, 1958, Doubleday & Company, Inc;
The Bug Book, 1960, Epstein & Carroll; *The Fatal Lozenge*, 1960, *The Hapless Child*, 1961,
The Curious Sofa, 1961, *The Sinking Spell*, 1964, Ivan Obolensky, Inc.; *The Willowdale Handcar*,
1962, The Bobbs-Merrill Company Inc.; *The Wuggly Ump*, 1963, J.B. Lippincott Company;
The Gashlycrumb Tinies, 1963, *The Insect God*, 1963, *The West Wing*, 1963, *The Remembered Visit*,
1965, Simon and Schuster. The author and publisher acknowledge with special thanks all courtesies of
the foregoing publishers.

Visit our website at www.penguin.com

PRINTING HISTORY
G. P. Putnam's Sons hardcover edition / October 1975
Perigee trade paperback edition / May 1980

Perigee trade paperback ISBN: 978-0-399-50420-4

Printed in Mexico

48

Most Perigee Books are available at special quantity discounts for bulk purchases for sales promotions,
premiums, fund-raising, or educational use. Special books, or book excerpts, can also be created to
fit specific needs. For details, write: Special Markets, Penguin Group (USA) Inc., 375 Hudson Street,
New York, New York 10014.

For **T**om Fitzharris

Contents

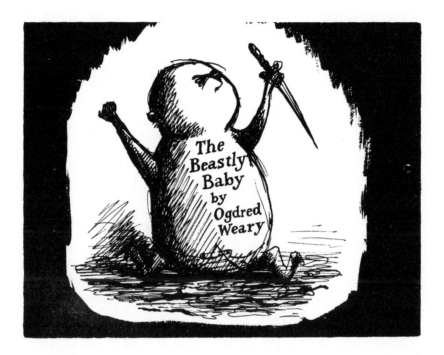

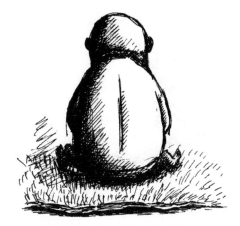

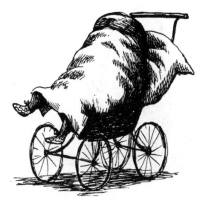

Once upon a time there was a baby.

It was worse than other babies. For one thing, it was larger.

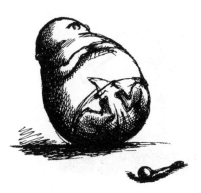

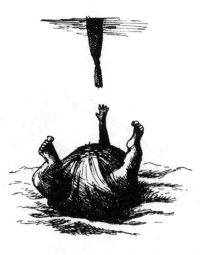

Its body was not merely obese, but downright bloated.

One of its feet had too many toes, and the other one not enough.

Its hands were both left ones.

Its nose was beaky, and appeared to be considerably older than the rest of it.

Its tiny eyes were surrounded by large black rings due to fatigue, for its guilty conscience hardly <u>ever</u> allowed it to sleep.

It was usually damp and sticky for it wept a great deal. It was consumed by self-pity, which in this case was perfectly justified.

It was capable of making only two sorts of noises, both of them nasty.

The first was a choked gurgling, reminiscent of faulty drains. It made this noise when it had succeeded in doing something particularly atrocious.

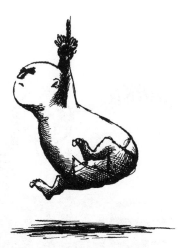

The second was a thin shriek suggestive of fingernails on blackboards. It made this noise when it had been prevented from doing something particularly atrocious.

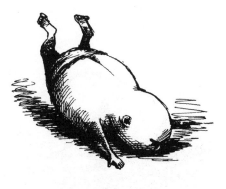

Fortunately, it was unable to walk.

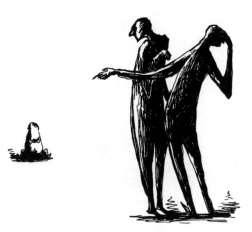

It had never been given a name since no-one cared to talk about it. When it was absolutely necessary to do so, it was referred to as the Beastly Baby.

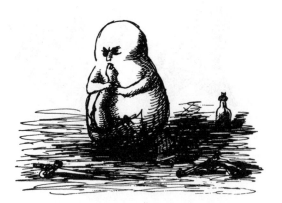

Dangerous objects were left about in the hope that it would do itself an injury, preferably fatal.

But it never did, and instead, hacked up the carpets with knives.

Or burnt enormous holes in the upholstery with acid.

Or shot bric-à-brac off the tables.

A day in the broiling sun had no other effect than to turn it a horrid purple.

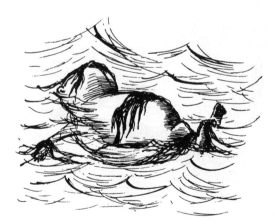

When it was taken bathing, it always floated back to shore, festooned with slimy green weed.

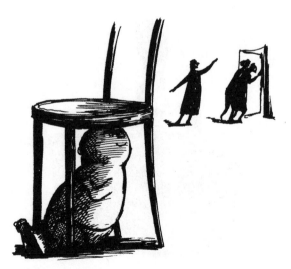

In public places some officious person was certain to point out that it was in danger of being left behind.

Inevitably, a policeman was looking on whenever it was just about to be momentarily set down on a doorstep.

In the meantime it grew larger and older every day, and what this would eventually lead to, no-one liked to think.

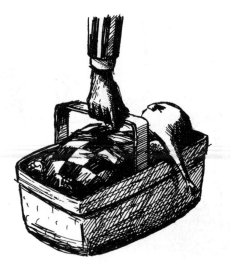

Then one day it was taken on a picnic.

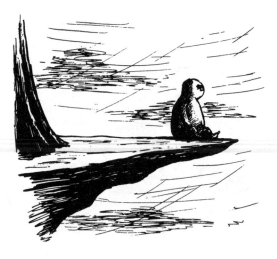

It was set on an exposed ledge some distance from where the food was.

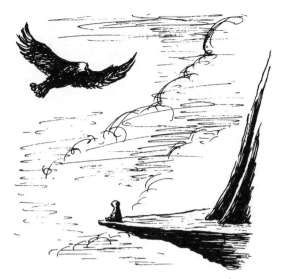

A few minutes later, a passing eagle
noticed it there.

The eagle, having never before been
presented with this classic opportunity,
carried it off.

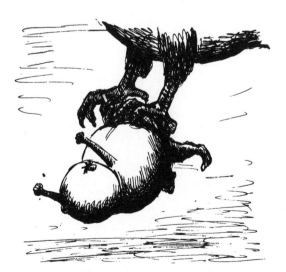

The eagle found keeping hold of it more
difficult than he had expected.

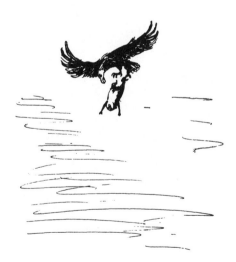

He attempted to get a further grip on it
with his beak.

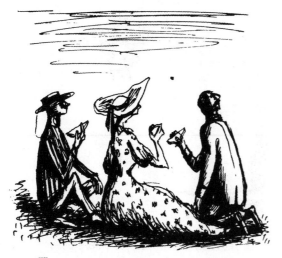

There was a wet sort of explosion, audible for several miles.

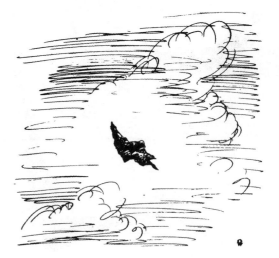

And _that_, thank heavens! was the end of the Beastly Baby.

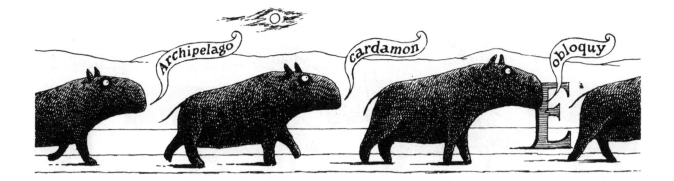

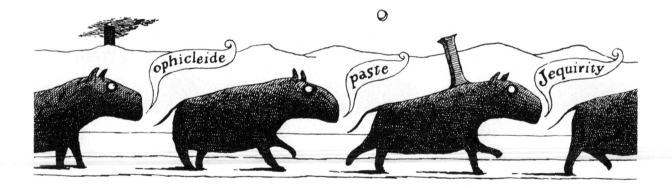

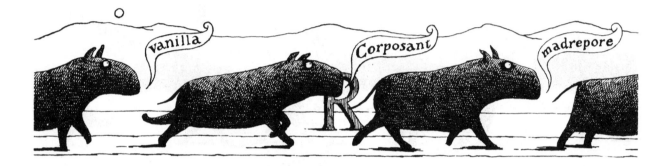

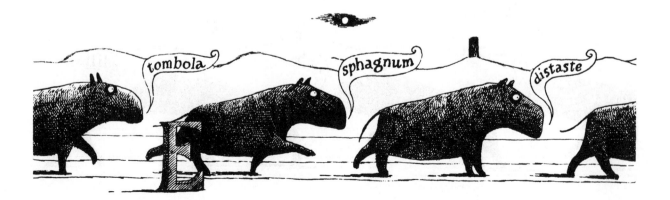

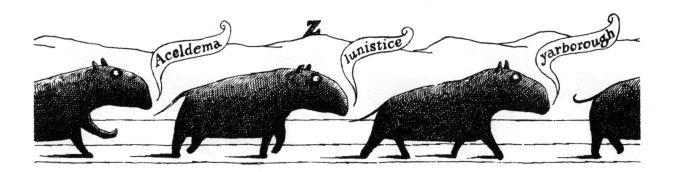

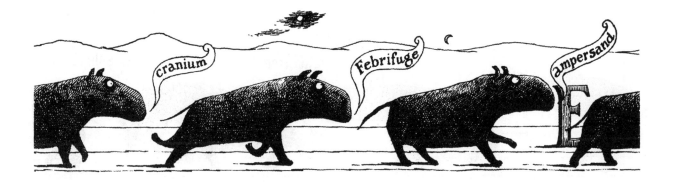

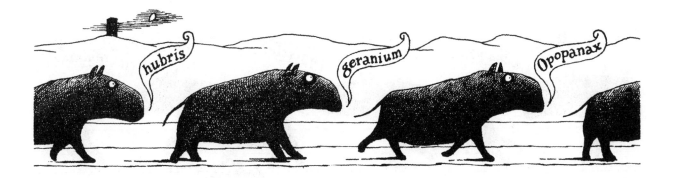

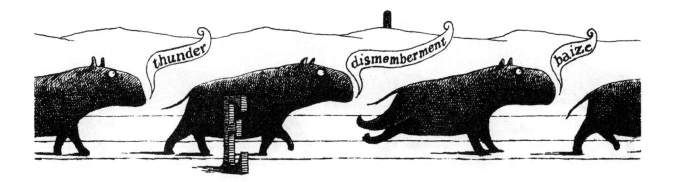

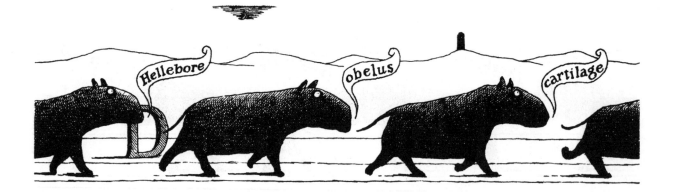

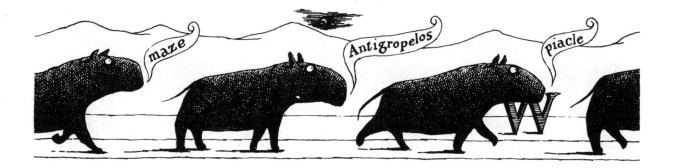

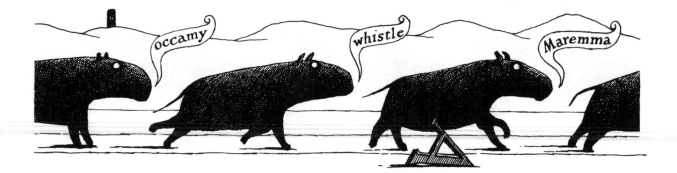

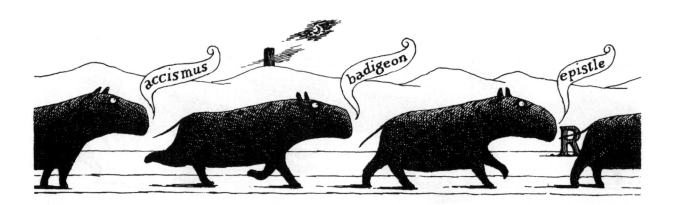

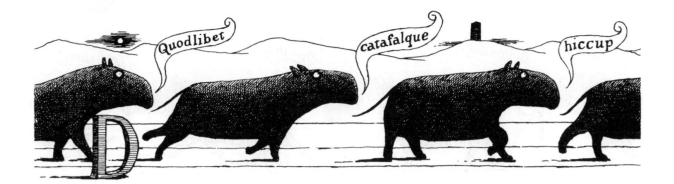
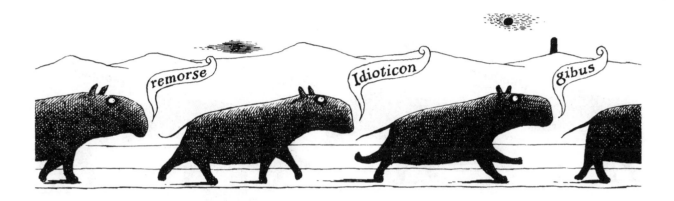
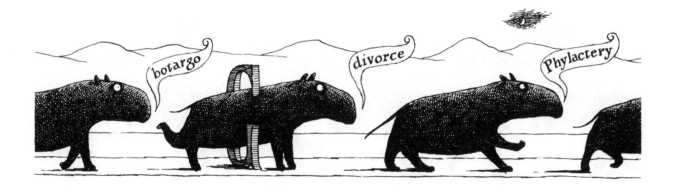
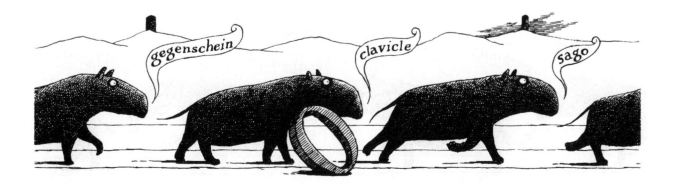

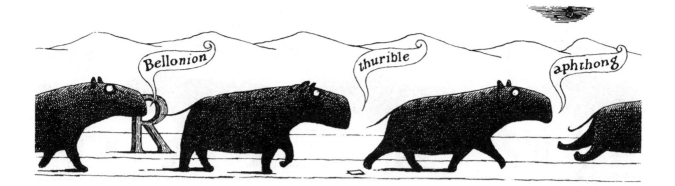

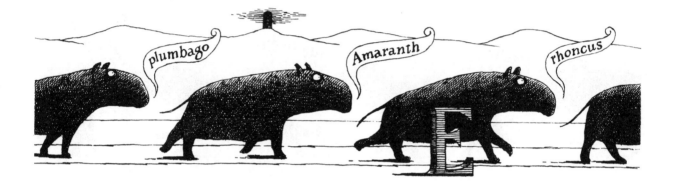

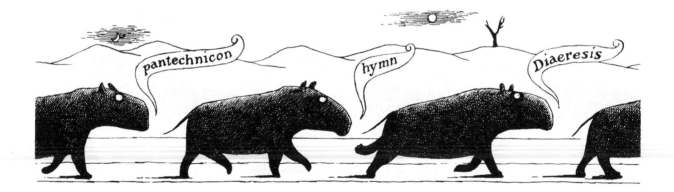

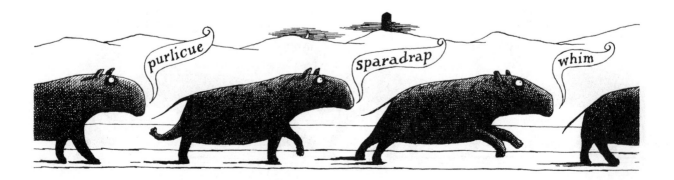

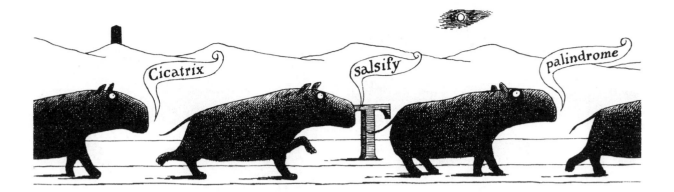

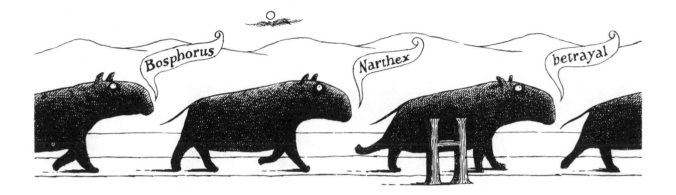

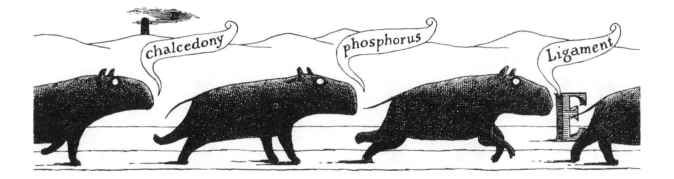

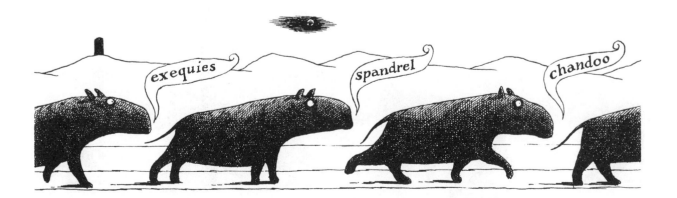

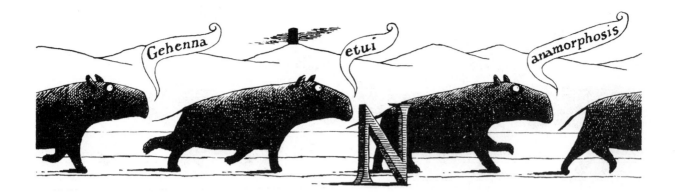

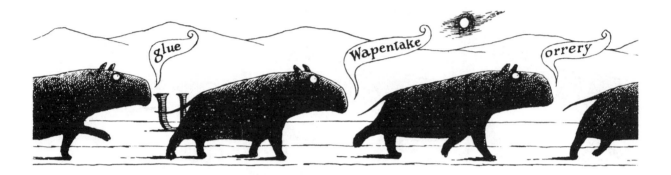

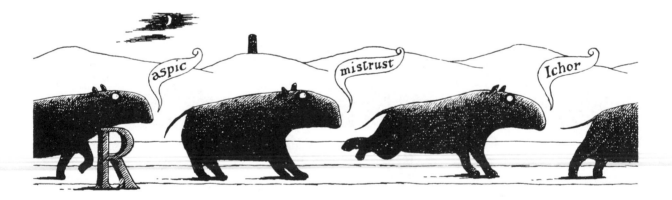

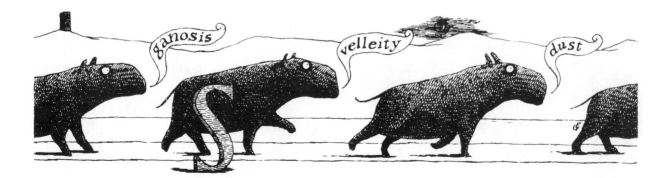

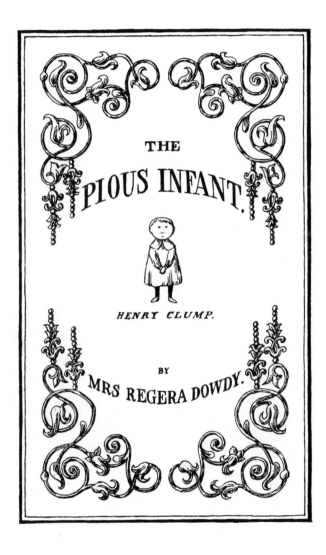

THE

PIOUS INFANT.

HENRY CLUMP.

BY

MRS REGERA DOWDY.

3.

Little Henry Clump was scarce-
ly three years old when he
found out that his heart was
wicked, but that God loved
him nevertheless.

He soon learnt a great many
texts and hymns, and was
always saying them over to
himself.

Once when he saw a sea-gull rise
up from the waves 'Look, look!'
he said to his sister, Fanny Eliza.
'When I die I shall go up to
heaven like that bird.'

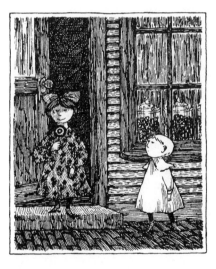

He habitually went without
sweet things so that he might
give pennies to stop the poor
heathen from bowing down
to idols.

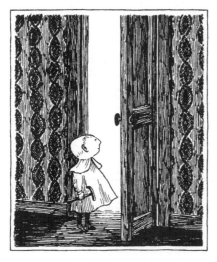

He dearly loved his parents
and never tired of asking
what he might do for them.

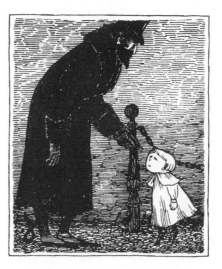

Although he was kind and good,
he was sometimes tempted by
Satan, but he felt his sins
deeply and was truly sorry
for them afterwards.

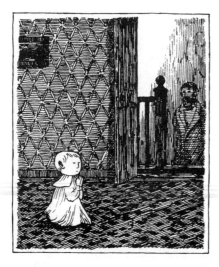

He was often discovered alone
upstairs on his knees.

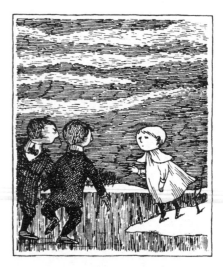

One Sunday he saw some boys sliding
on the ice; he went up to them and
said 'Oh, what a shame it is for you
to idle on the Sabbath instead of
reading your Bibles!'

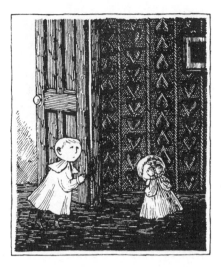

He was very fond of Fanny Eliza
and, whenever she got into a
passion, became much concerned
for the salvation of her soul.

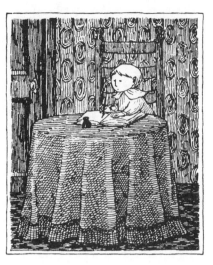

He used to go through books
and carefully blot out any
places where there was a friv-
olous mention of the Deity.

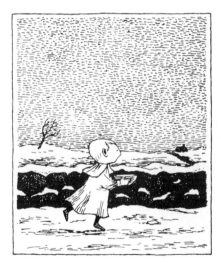

On a winter afternoon when he
was four years and five months
old he went to give his bread-
pudding to an unfortunate
widow.

As he was returning home a
great black cloud came up
and large hailstones fell
in profusion.

That night he had a sore
throat, which by morning had
turned into a fatal illness.

His last words were 'God loves
me and has pardoned all my
sins. I am happy!' before
he fell back pale and still
and dead.

Henry Clump's little body turned
to dust in the grave, but his
soul went up to God.

The Evil Garden

by Eduard Blutig

THE EVIL GARDEN

Eduard Blutig's Der Böse Garten
in a translation by Mrs Regera Dowdy
with the original pictures of O. Müde
The Fantod Press, New York, 1966

Alas, my translation of perhaps Herr Blutig's most famous
work appears on the melancholy occasion of the seventy-fifth
anniversary of the next to the next to the last time he
threw himself out of a window.

MRS R.D.

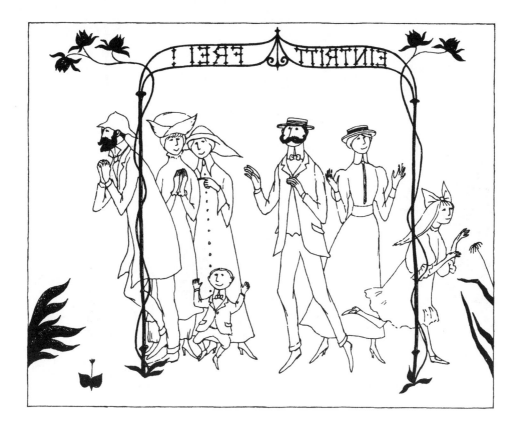

How *elegant*! how choice! how gay!
To think one doesn't have to pay.

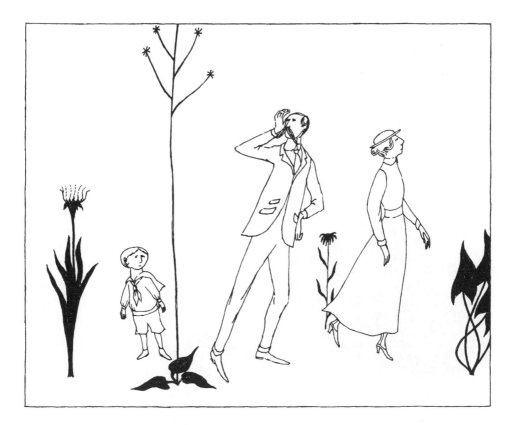

There is a sound of falling tears;
It comes from nowhere to the ears.

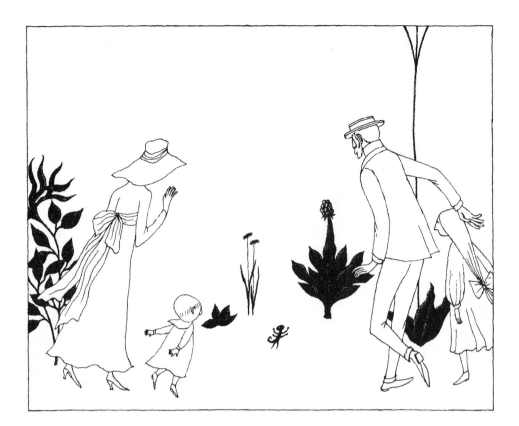

Some tiny creature, mad with wrath,
Is coming nearer on the path.

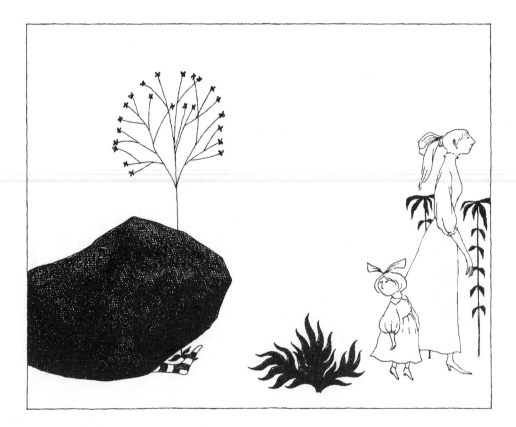

A foot inside a stripéd sock
Protrudes from underneath a rock.

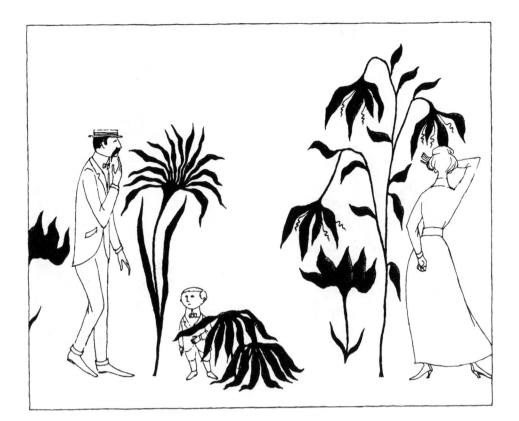

The gorgeous flowers have a smell
That causes one to feel unwell.

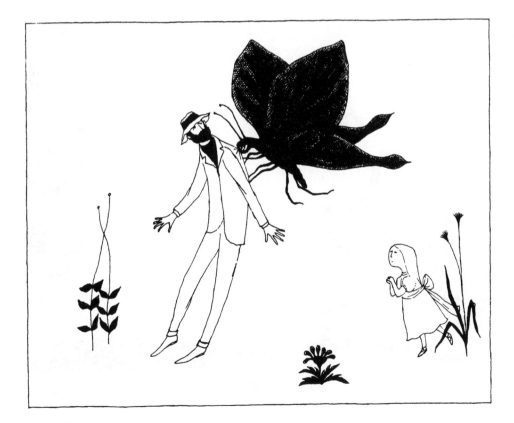

The Rev. Mr Floggle's cloth
Is being nibbled by a moth.

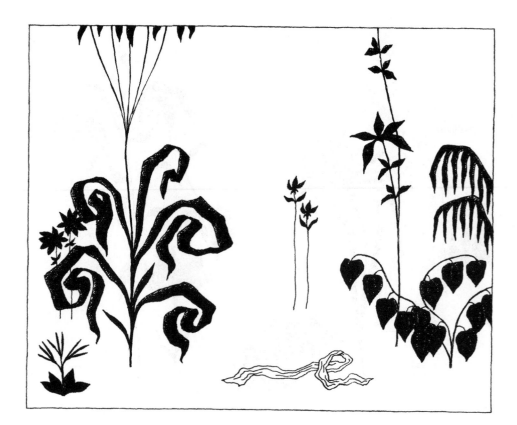

Her sash is lying on the ground,
But Isabelle cannot be found.

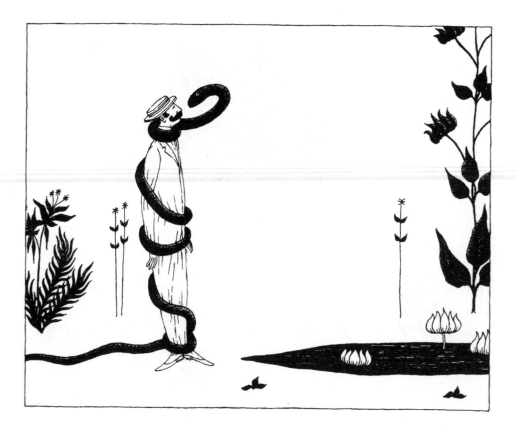

Great-Uncle Franz, beside the lake,
Is being strangled by a snake.

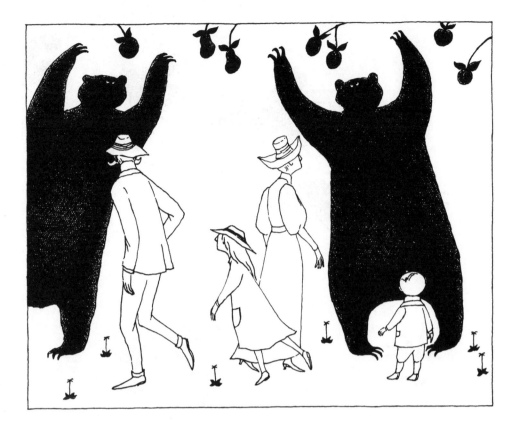

The peaches, apples, plums, and pears
Are guarded by ferocious bears.

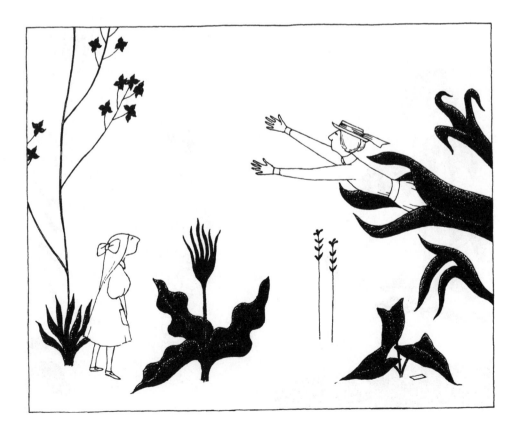

Alexa watches while her aunt
Is pulled feet first inside a plant.

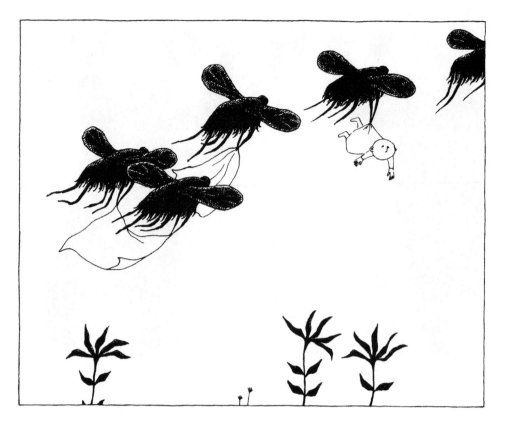

A hissing swarm of hairy bugs
Has got the baby and its rugs.

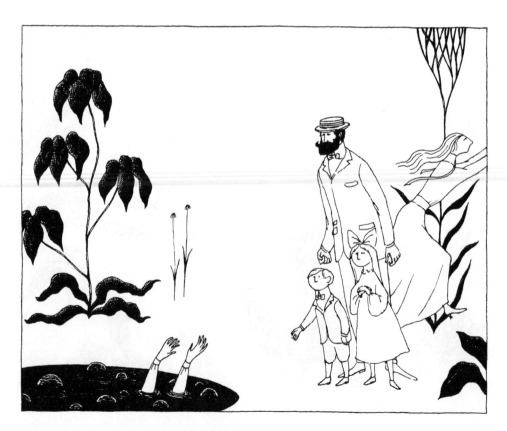

The nurse of whom they all were fond
Is sinking in the bubbling pond.

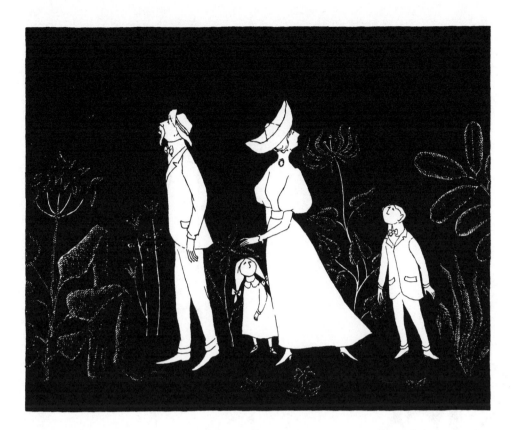

The sky has grown completely black;
It's time to think of turning back.

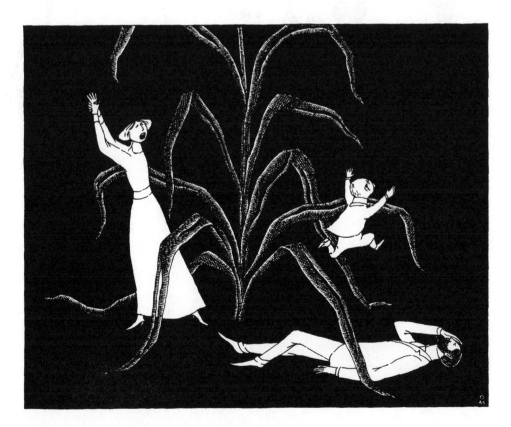

Fall down, or scream, or rush about—
There is no way of getting out.

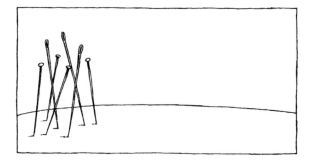

'Death and Distraction!' said the Pins and Needles. 'Destruction and Debauchery!'

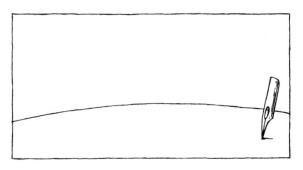

Almost at once the No. 37 Penpoint returned to the Featureless Expanse.

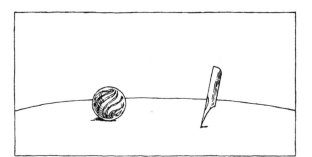

It encountered the Glass Marble, but neither recognized the other.

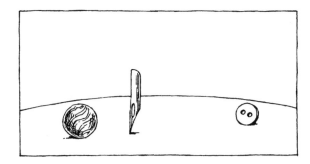

The Two-Holed Button concealed its apprehension.

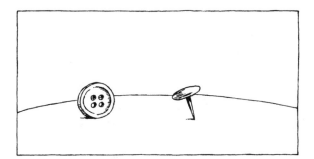

The Half-Inch Thumbtack told the Four-Holed Button what had happened.

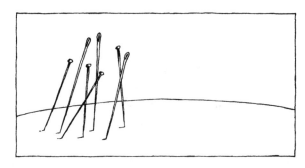

'Duplicity and Desolation!' said the Needles and Pins. 'Dissolution and Despair!'

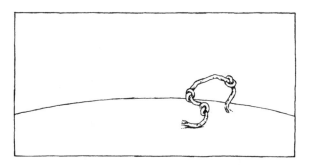

Quickly the Knotted String decided to wait on events.

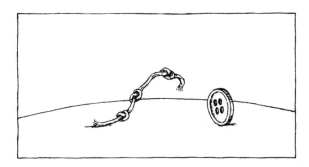

The Four-Holed Button came to it with a sinister proposal.

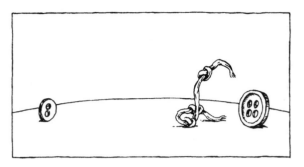

The Two-Holed Button overheard them unnoticed.

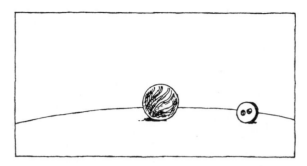

No sooner had it withdrawn than it ran into the Glass Marble.

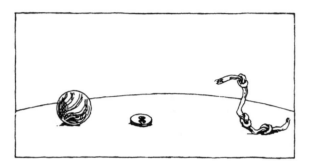

The Knotted String appeared and the Two-Holed Button fell senseless.

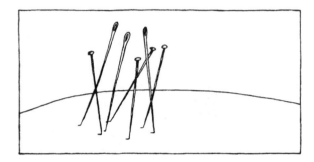

'Discomfort and Damage!' said the Pins and Needles. 'Doom and Discrepancy!'

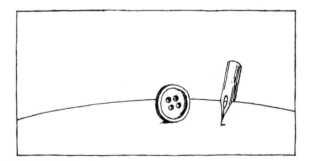

Incontinently the Four-Holed Button approached the No. 37 Penpoint with another sinister proposal.

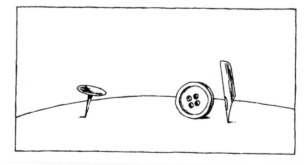

The Half-Inch Thumbtack informed them what had taken place.

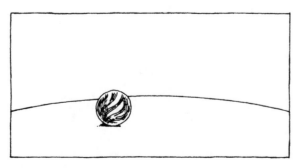

The Glass Marble regretted its actions.

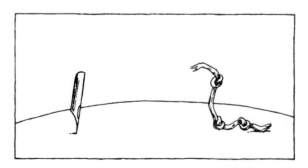

The No. 37 Penpoint and the Knotted String confronted one another.

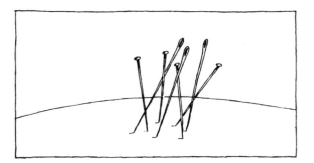

'Dishonour and Depredation!' said the Needles and Pins. 'Degradation and Dismay!'

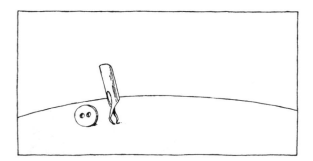

Immediately the No. 37 Penpoint, now ruined, and the Two-Holed Button fled.

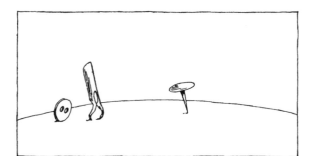

The Half-Inch Thumbtack acquainted them with what had transpired.

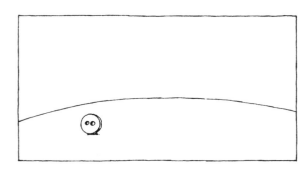

The Two-Holed Button found itself alone.

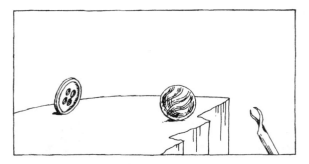

The Glass Marble, mistaking the No. 37 Penpoint for the Four-Holed Button, pushed it into the Yawning Chasm.

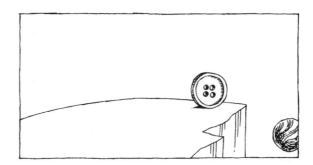

When it saw what it had done, it went mad and rolled off the edge.

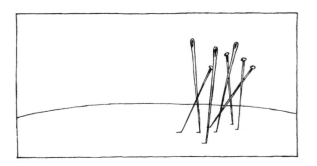

'Danger and Deceit!' said the Pins and Needles. 'Defeat and Disaster!'

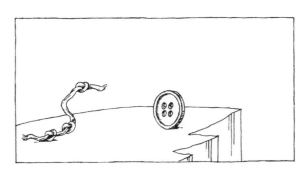

Promptly the Knotted String surprised the Four-Holed Button.

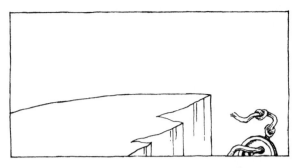

In the struggle they went over the edge together.

The Half-Inch Thumbtack made known to the Two-Holed Button what had occurred.

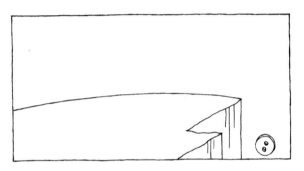

The Two-Holed Button threw itself over at the same spot.

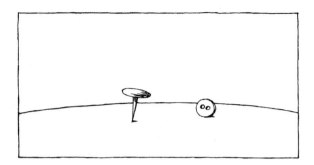

The Half-Inch Thumbtack looked around and fell down lifeless.

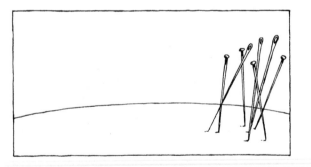

'Depravity and Disappointment!' said the Needles and Pins. 'Disappearance and Damnation!'

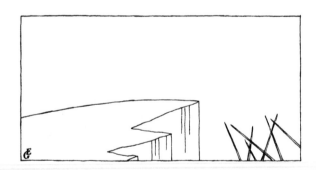

Forthwith they too flung themselves into the Yawning Chasm.

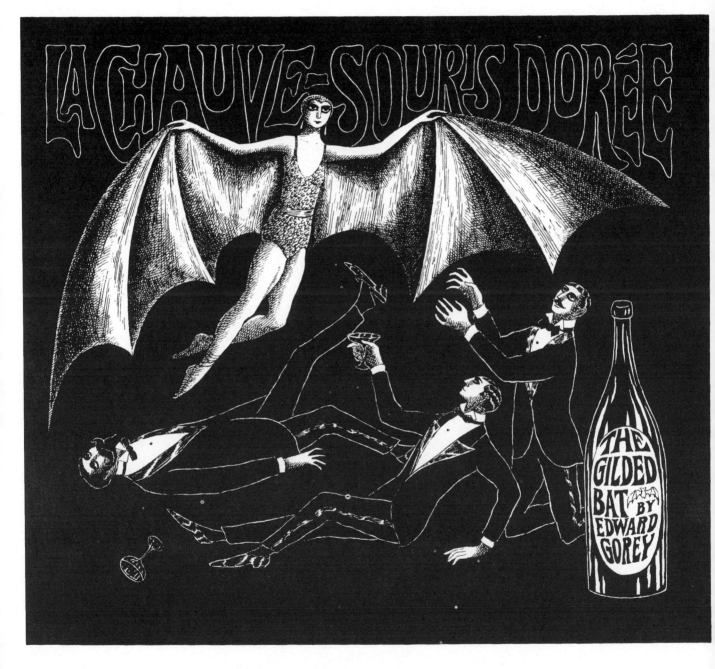

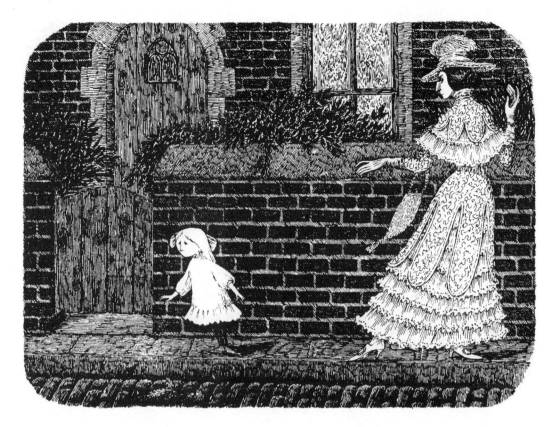

Maudie was only five when she was discovered gazing at a dead bird by Madame Trepidovska.

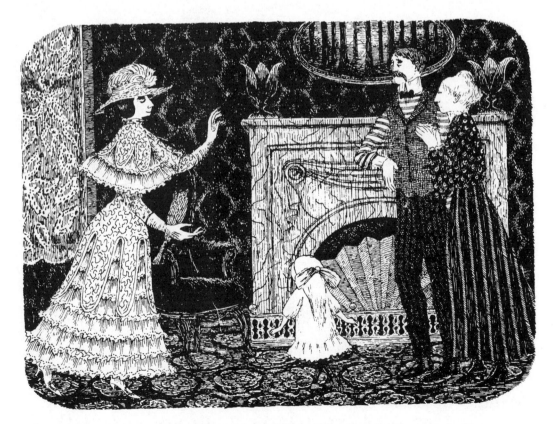

Madame, once *assoluta* at the Maryinsky, informed the Splaytoes that the child was to be her pupil.

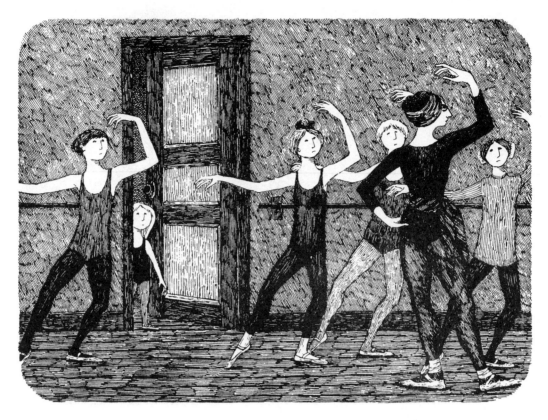

Long years of study began in her ballet school above a row
of shops.

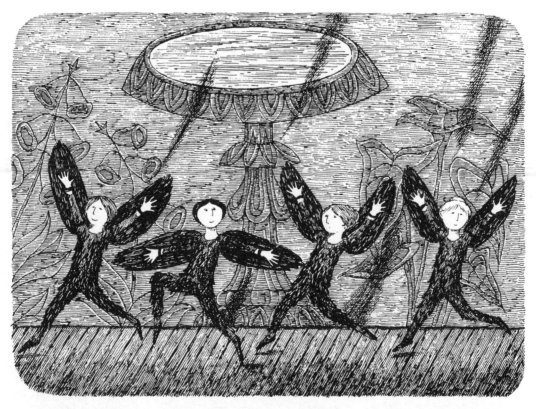

Maudie first came before the public as a sparrow in *Bain
d'Oiseaux*, devised by Madame to display her students'
abilities.

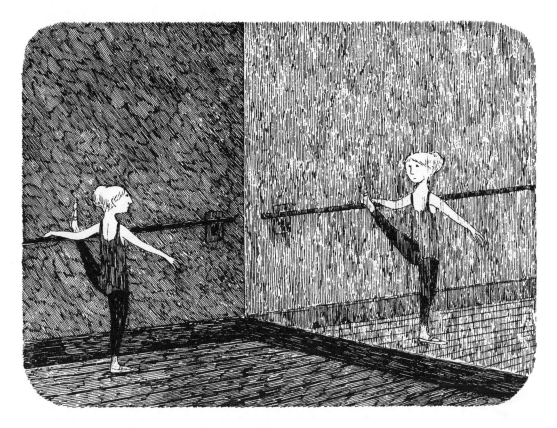

Her life was rather monotonous.

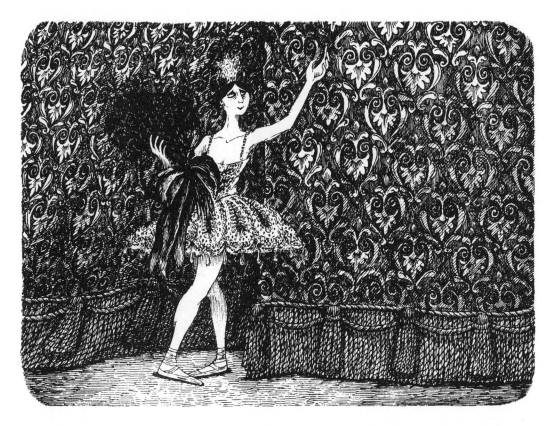

She became aware of what real ballet was when Madame took her to one of Solepsiskaya's innumerable farewell performances.

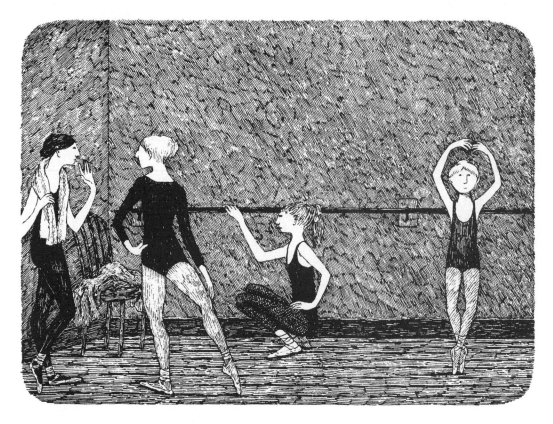

Eventually she was allowed to go up on point.

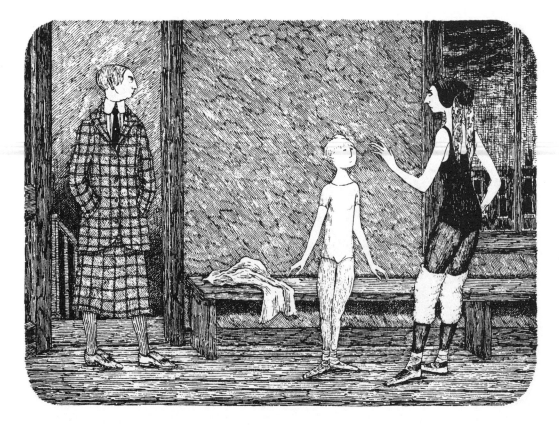

Miss Marshgrass, the school's backer, took exception to
Madame's interest in Maud; there were scenes.

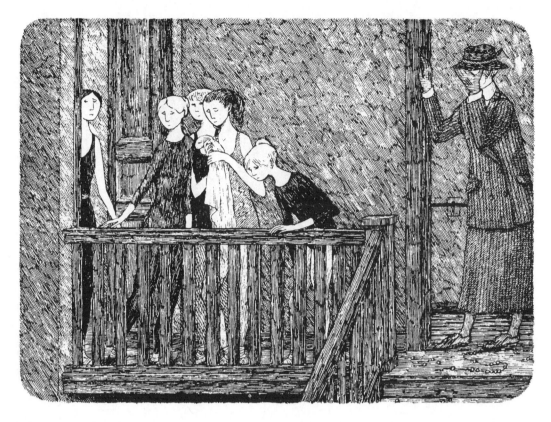

Madame had to be removed to a private lunatic asylum, and the school was shut down.

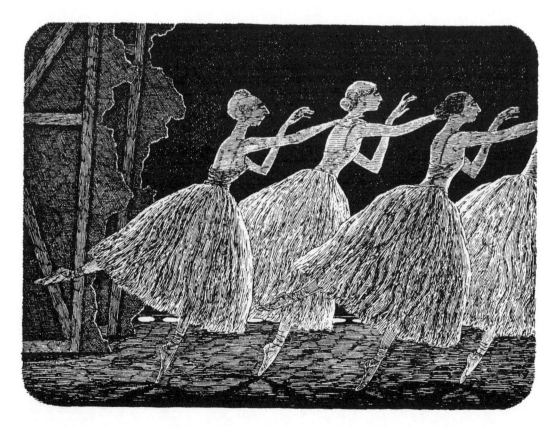

Maud obtained a place in the corps of the Ballet Hochepot.

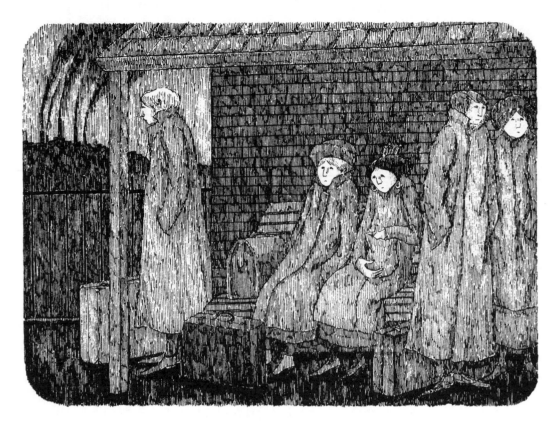

For the next two years she danced in the provinces.

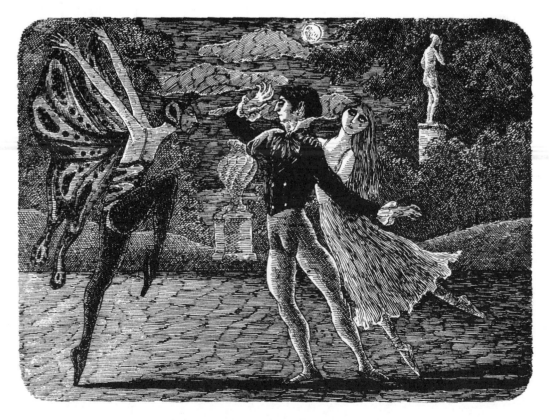

She was given her first solo as the Papillon Enragé in a revival of Golopine's *Jardin de Regrets*; others followed.

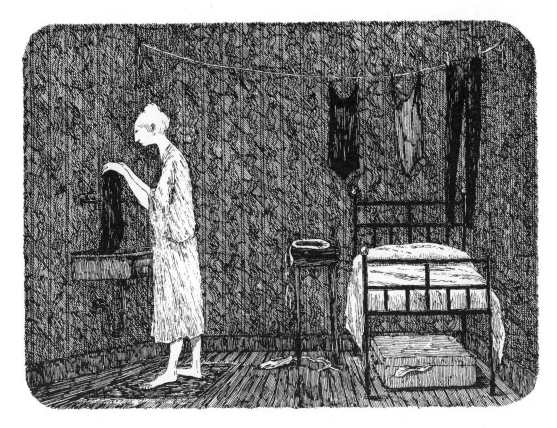

Her life went on being fairly tedious.

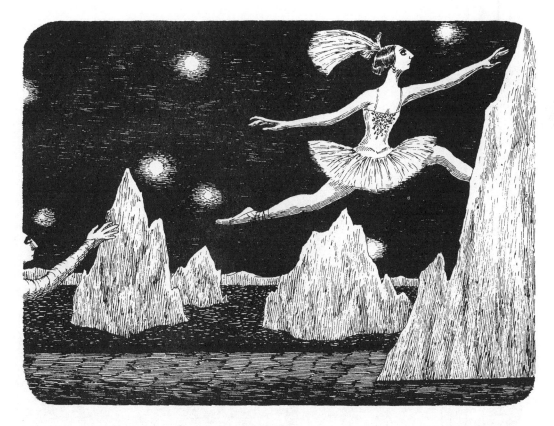

After Federojenska did a grand jeté into the wings one matinee
and was never seen again, Maud took over *Oiseau de Glace* to
great acclaim.

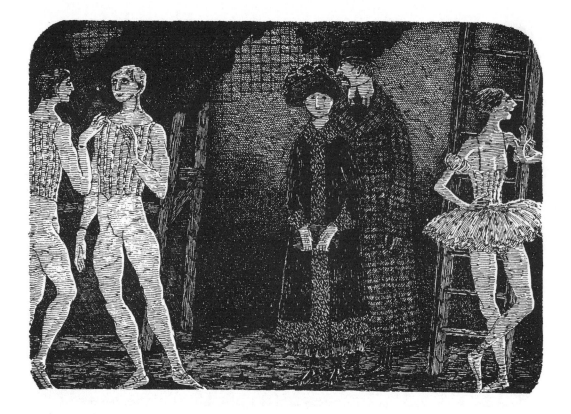

Her parents only once came to visit her backstage.

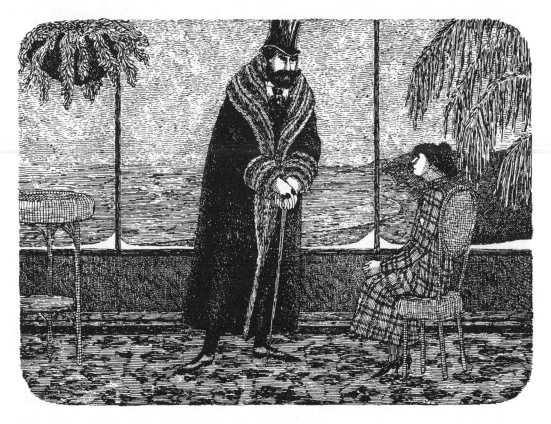

Baron de Zabrus invited her to join his company, the most renowned in Europe.

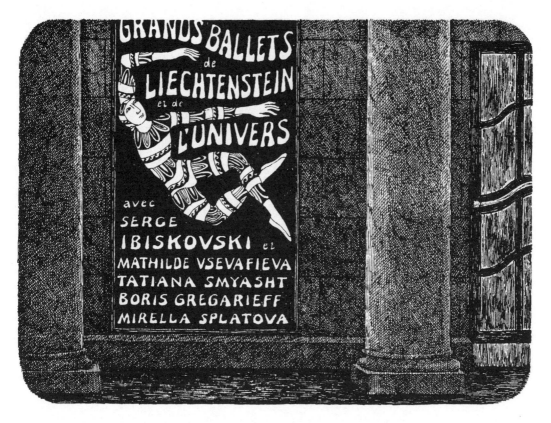

He changed her name to something more exotic.

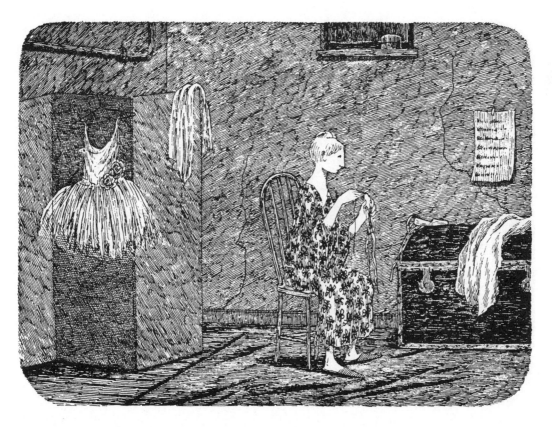

Her life did not cease to be somewhat dreary.

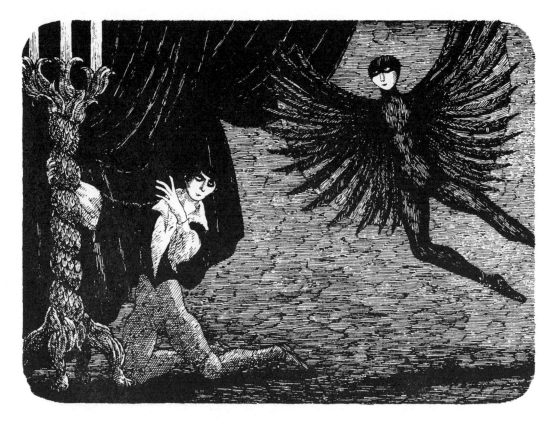

The Baron chose her to dance a new pas de deux, *Le Corbeau* (d'après E.A.Poe), with Ibiskovski.

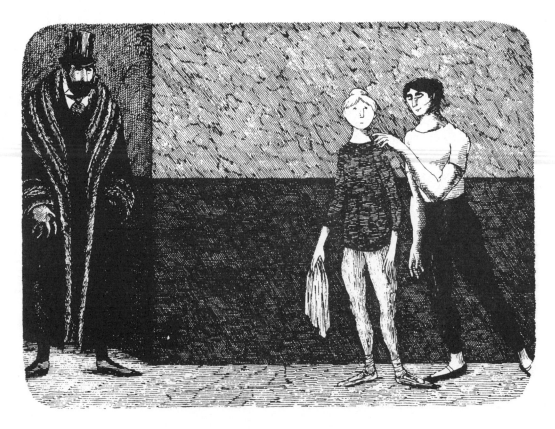

Serge developed an unlikely infatuation for her.

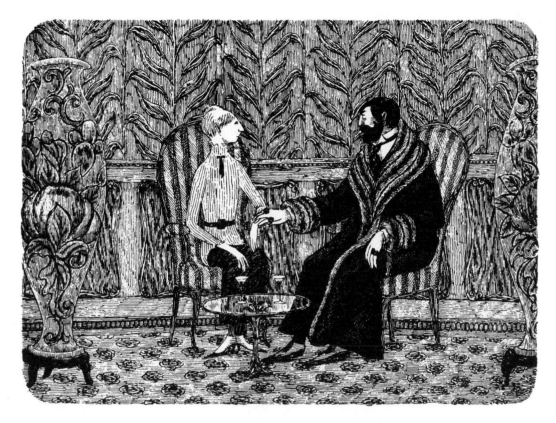

The Baron told her that only art meant anything.

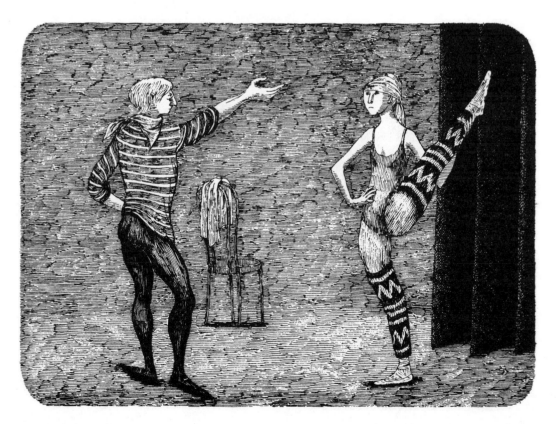

Plastikoff created for her a new ballet, *La Chauve-Souris Dorée*; it was his greatest work.

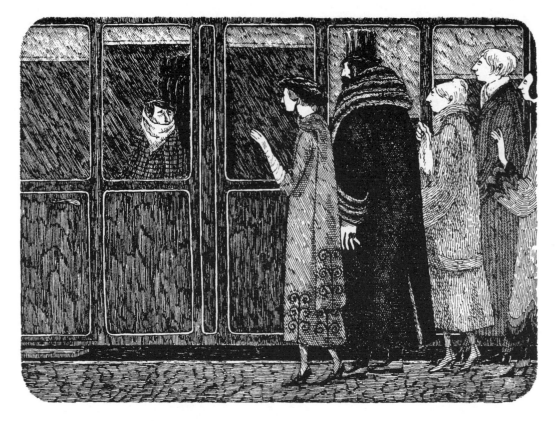

Serge began to cough a lot, and had to go away to a sanitorium outside Zug.

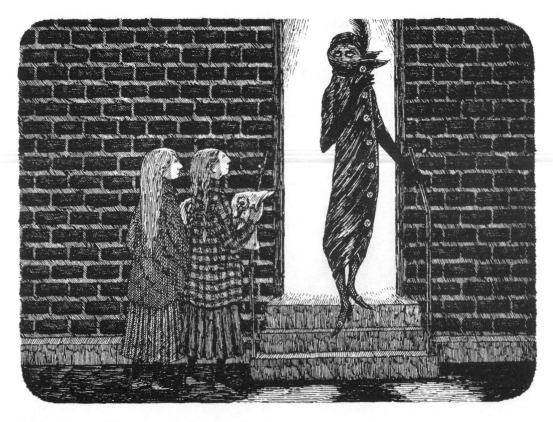

Mirella all at once became chic and mysterious.

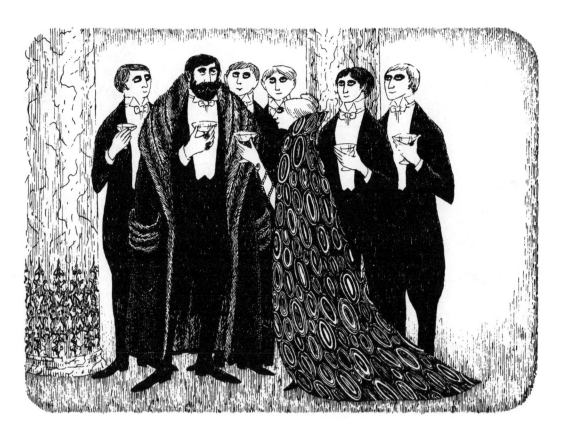

She was seen everywhere with the Baron.

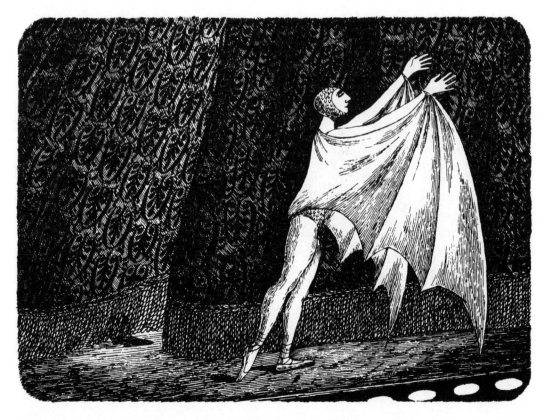

She had become the reigning ballerina of the age, and one of its symbols.

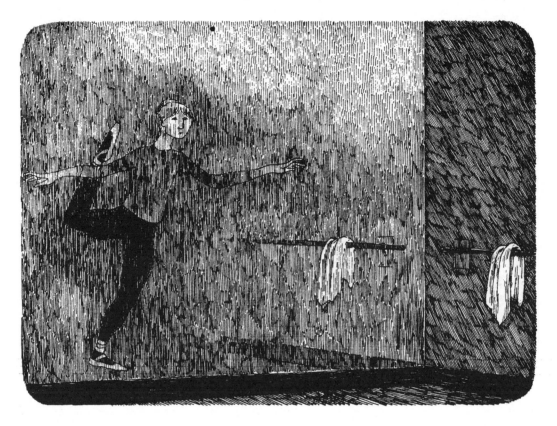

Her life was really *no* different from what it had ever been.

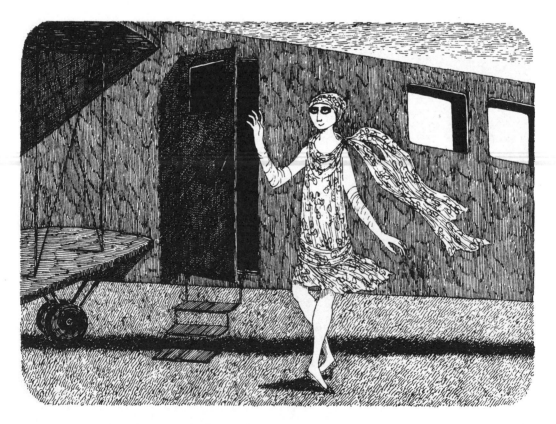

She was asked to dance in a charity gala before royalty
at Cagnes-sur-Mer.

Over the Camargue a great dark bird flew into the propeller of the aeroplane.

At the gala her costume was suspended from the centre of the stage while the music for her most famous variation was played in her memory.

The people at the grey hotel

Are either aged or unwell.

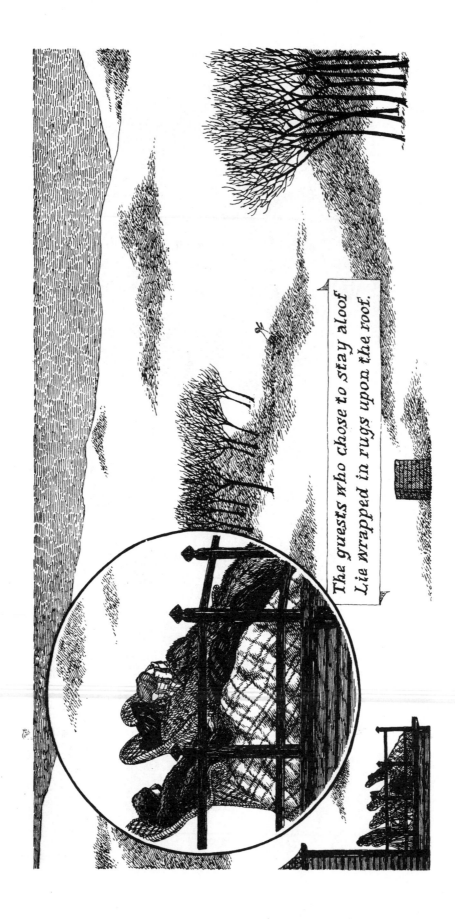

The guests who chose to stay aloof
Lie wrapped in rugs upon the roof.

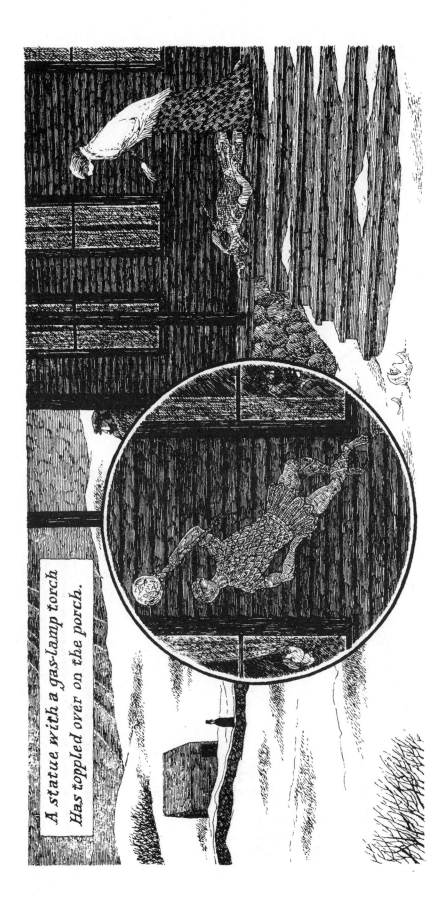

A statue with a gas-lamp torch
Has toppled over on the porch.

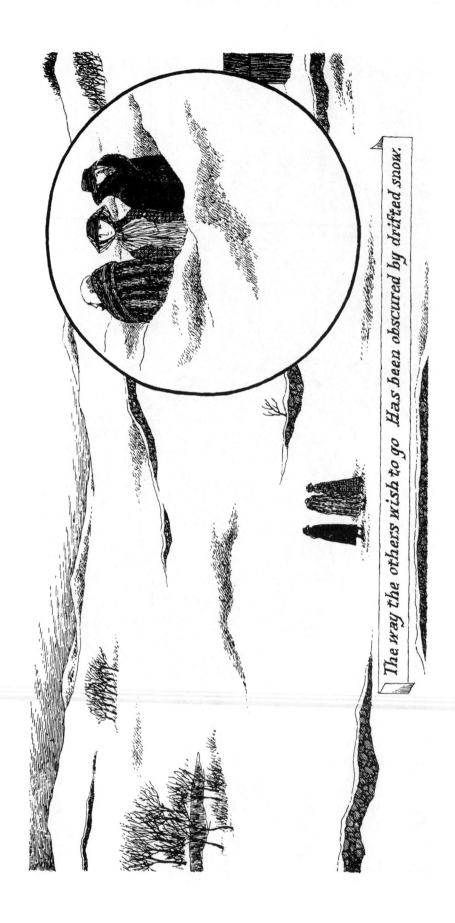

The way the others wish to go Has been obscured by drifted snow.

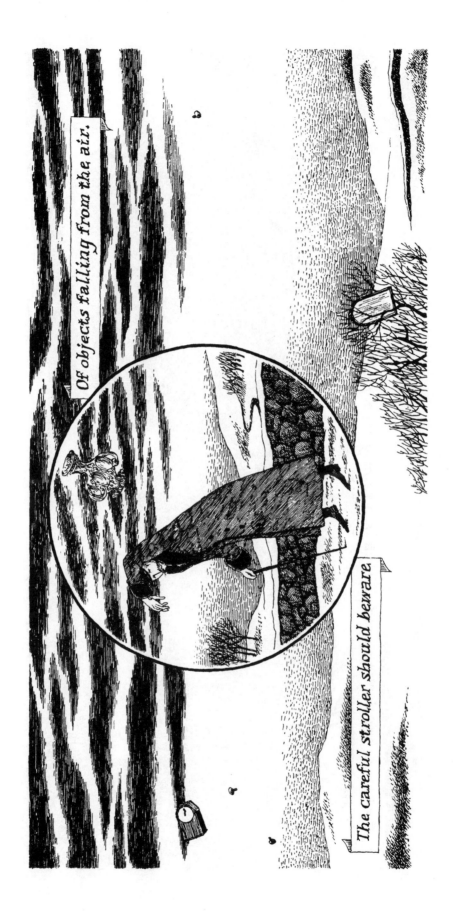

Of objects falling from the air.

The careful stroller should beware

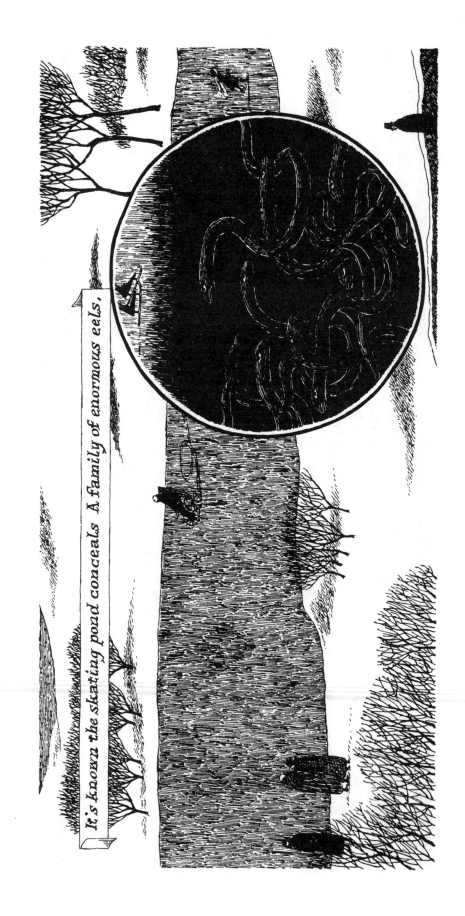

It's known the skating pond conceals A family of enormous eels.

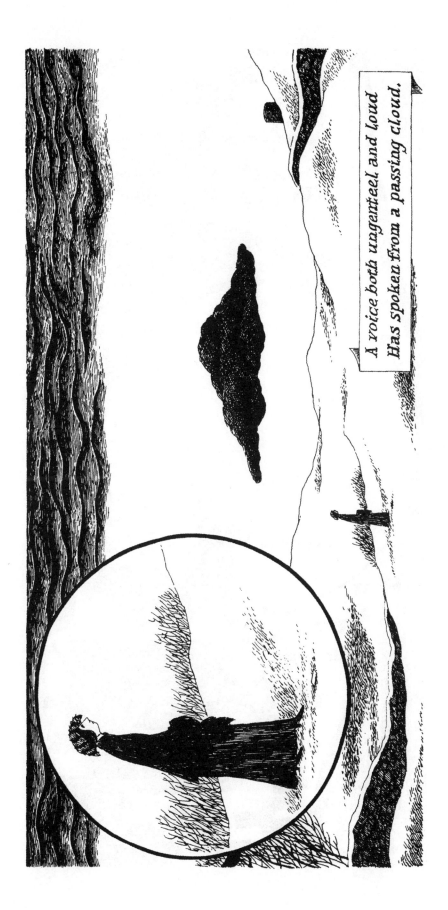

A voice both ungenteel and loud
Has spoken from a passing cloud.

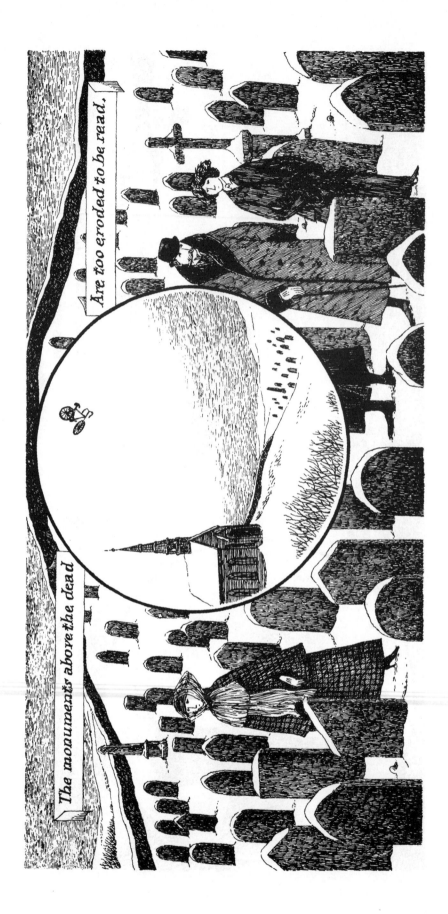

The monuments above the dead

Are too eroded to be read.

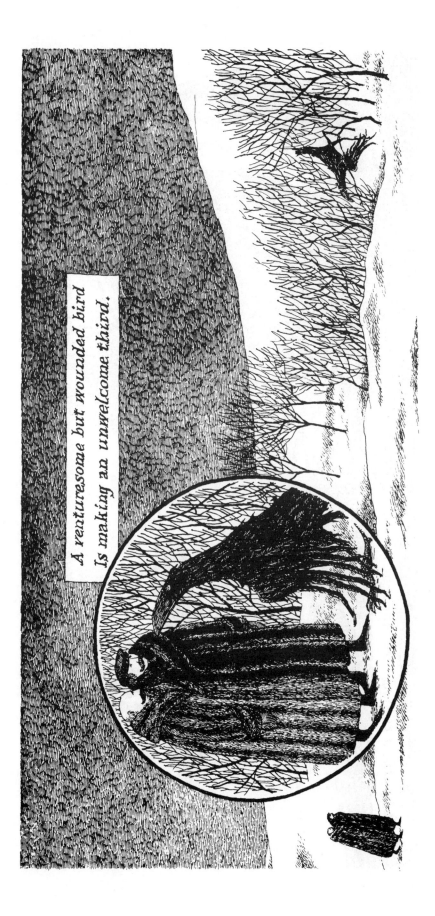

*A venturesome but wounded bird
Is making an unwelcome third.*

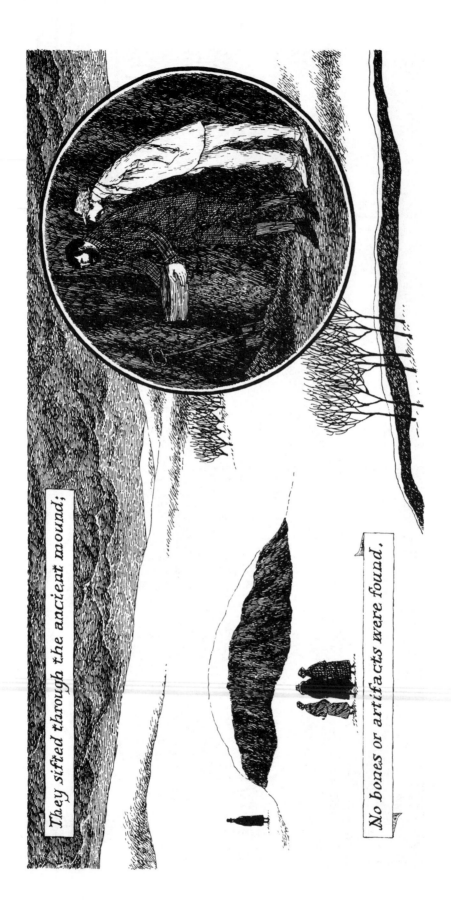

They sifted through the ancient mound;

No bones or artifacts were found.

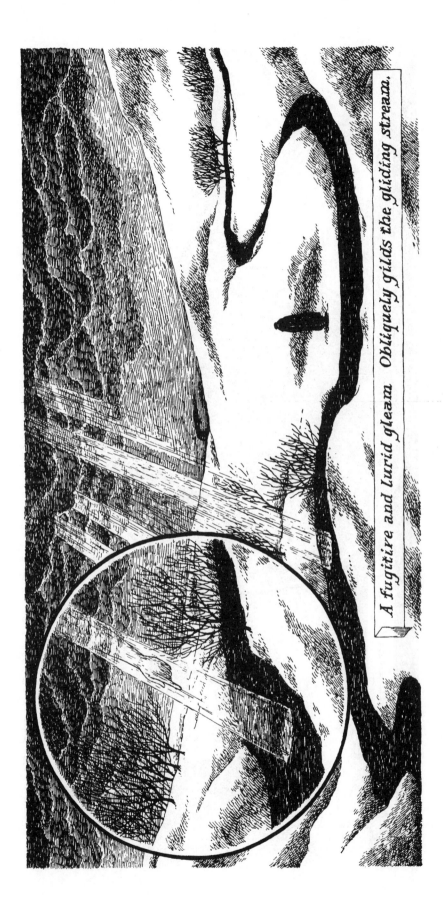

A fugitive and lurid gleam Obliquely gilds the gliding stream.

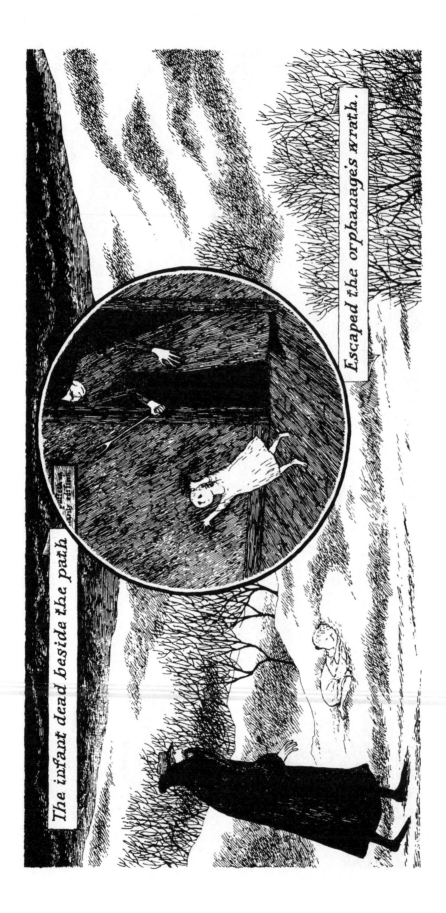

The infant dead beside the path.

Escaped the orphanage's wrath.

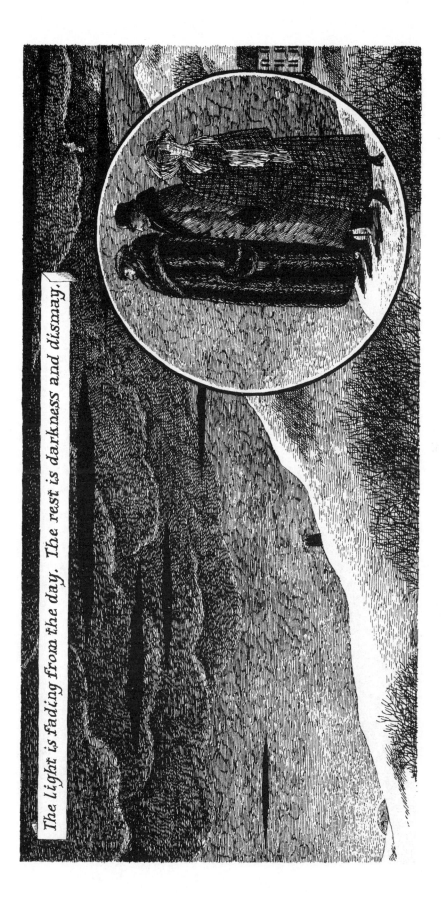

The Light is fading from the day. The rest is darkness and dismay.

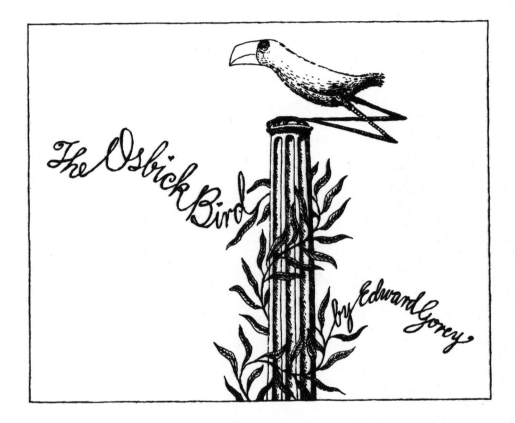

The Osbick Bird

by Edward Gorey

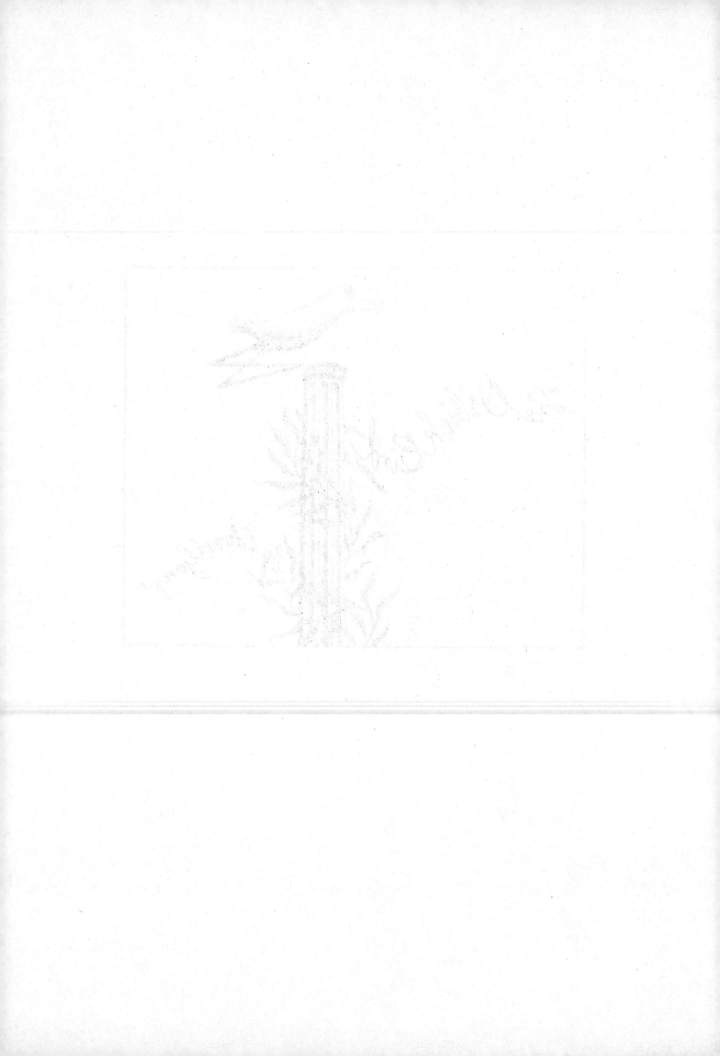

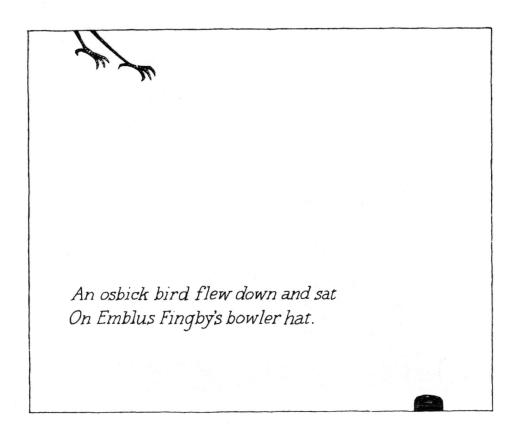

An osbick bird flew down and sat
On Emblus Fingby's bowler hat.

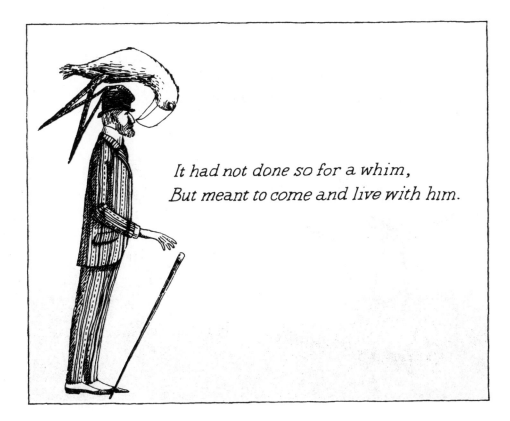

It had not done so for a whim,
But meant to come and live with him.

On Fridays Emblus played the flute;
The bird now joined him on a lute.

The top of the zagava tree
Was frequently where they had tea.

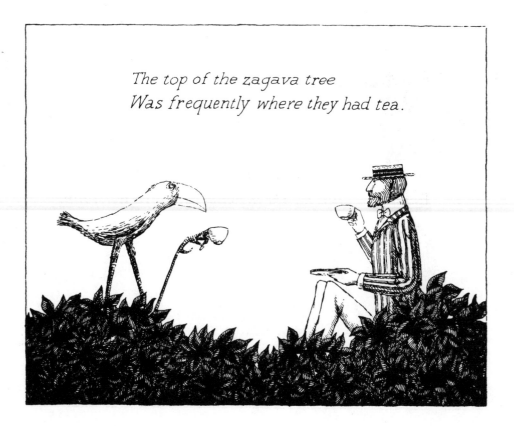

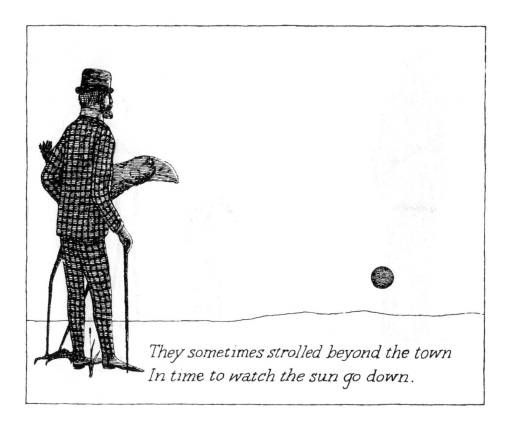

They sometimes strolled beyond the town
In time to watch the sun go down.

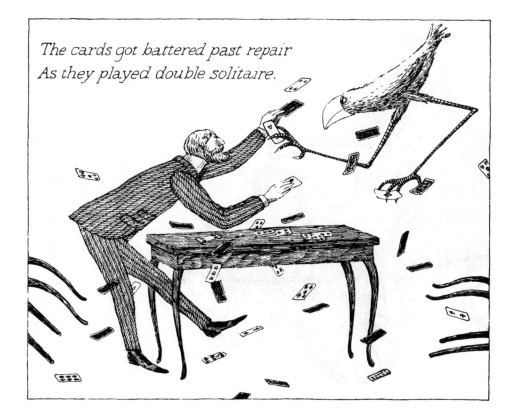

The cards got battered past repair
As they played double solitaire.

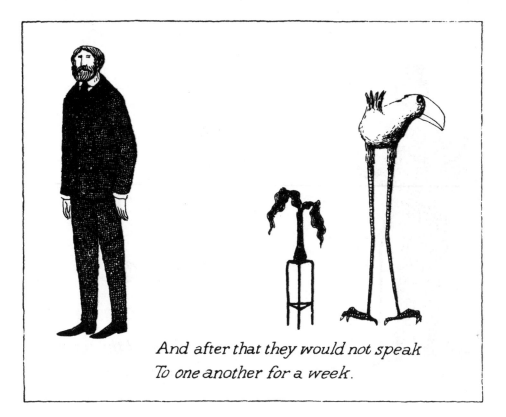

And after that they would not speak
To one another for a week.

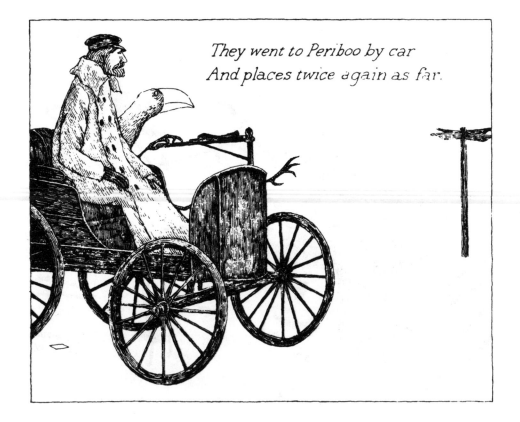

They went to Periboo by car
And places twice again as far.

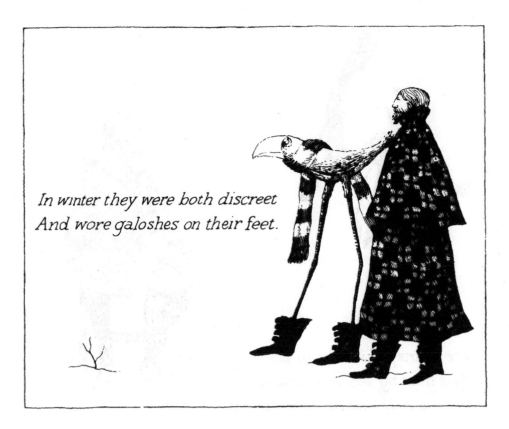

In winter they were both discreet
And wore galoshes on their feet.

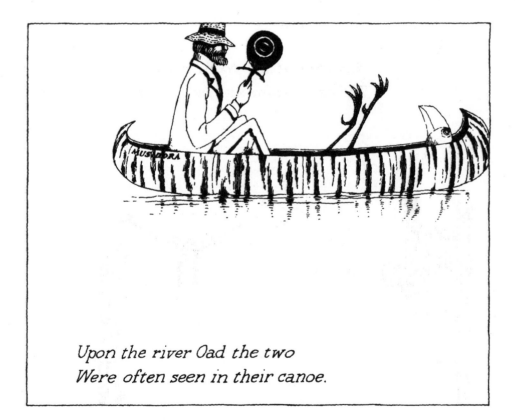

Upon the river Oad the two
Were often seen in their canoe.

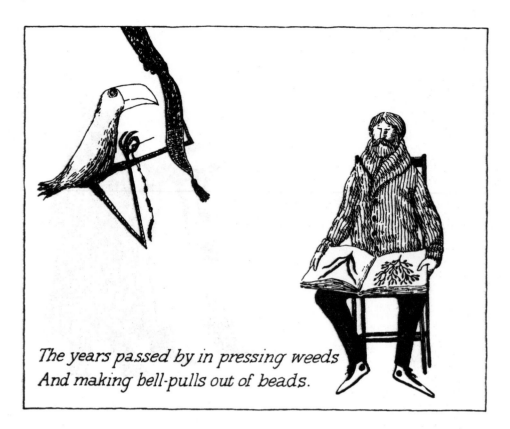

The years passed by in pressing weeds
And making bell-pulls out of beads.

And when at last poor Emblus died
The osbick bird was by his side.

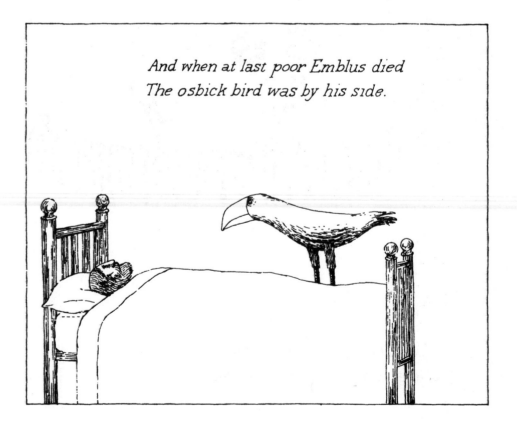

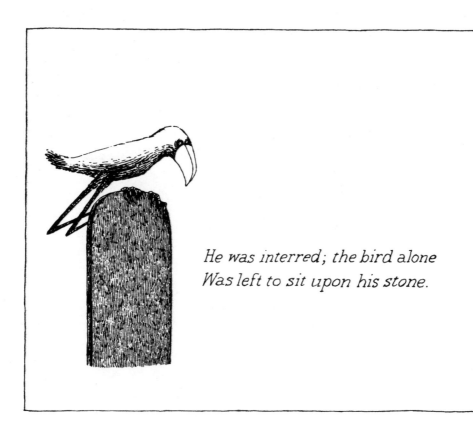

He was interred; the bird alone
Was left to sit upon his stone.

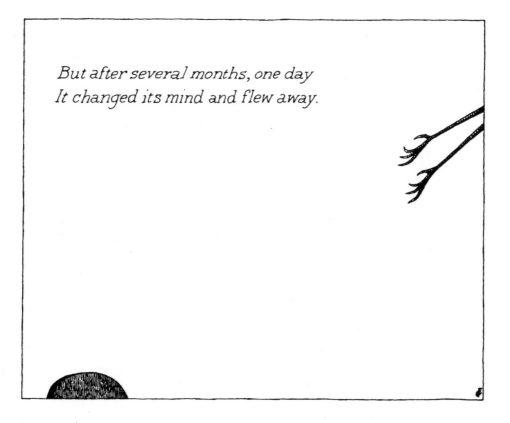

But after several months, one day
It changed its mind and flew away.

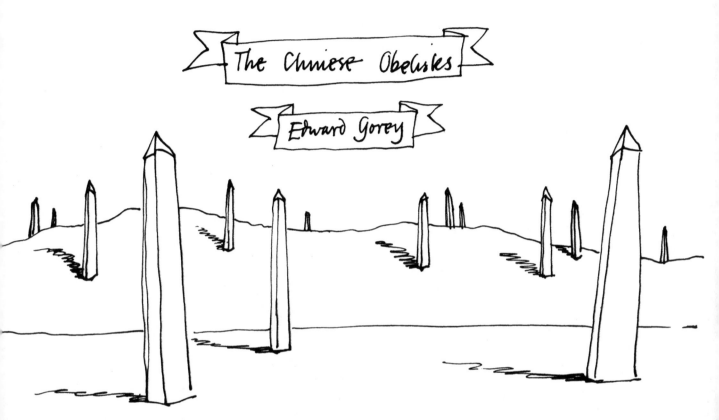

A was an Author who went for a walk

B was a Bore who engaged him in talk

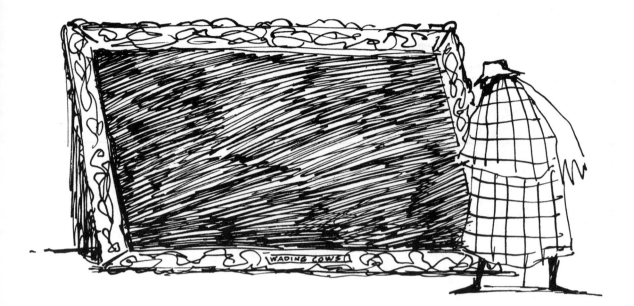

C was a Canvas encrusted with dirt

D was a Dog who appeared to be hurt

E an Egyptian with things from a tomb

F was a Fire in a top-storey room

G was the Glove that he dropped without thinking

H was a House whose foundations were sinking

I was an Infant who clung to his sleeve

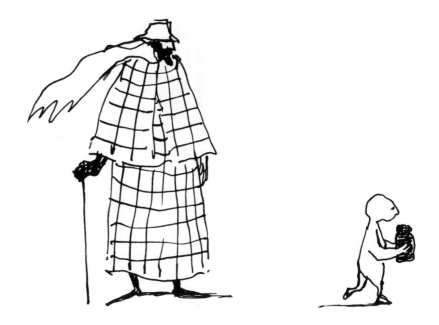

I was the Sam he gave it to leave

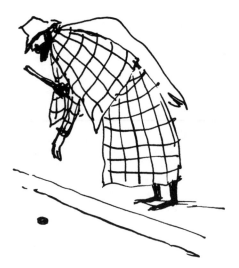

K was a Keepsake picked up from the gutter

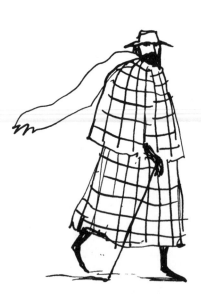

L was a Lady who peered through a shutter

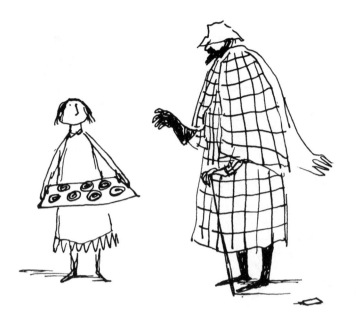

M was a Muffin he bought from a tray

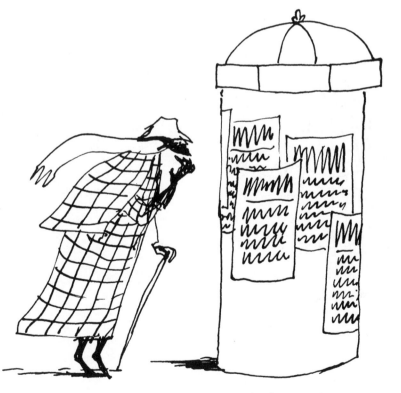

N was a Notice that caused him dismay

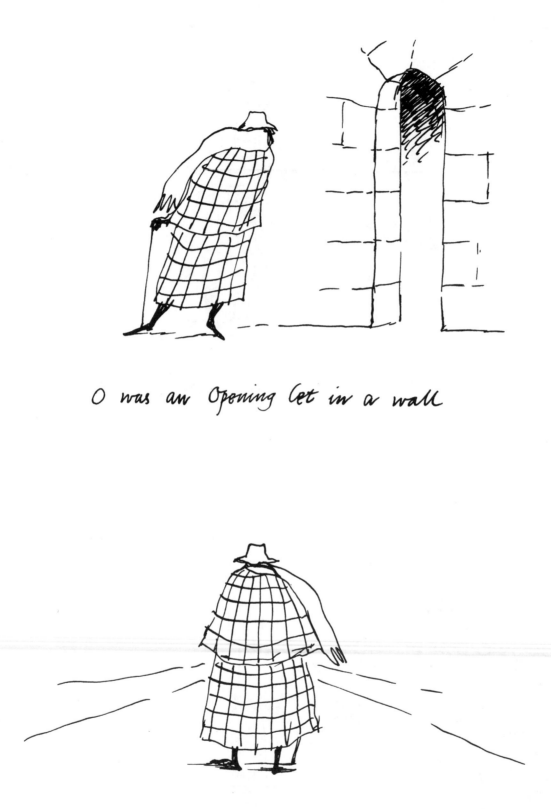

O was an Opening let in a wall

P was a Place he did not know at all

Q was the Question he asked of a stranger

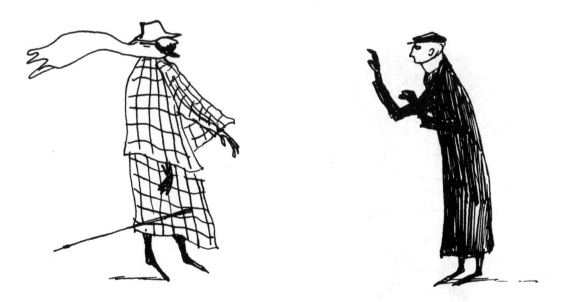

R the Reply that his life was in danger

S was the Sun which went under a cloud

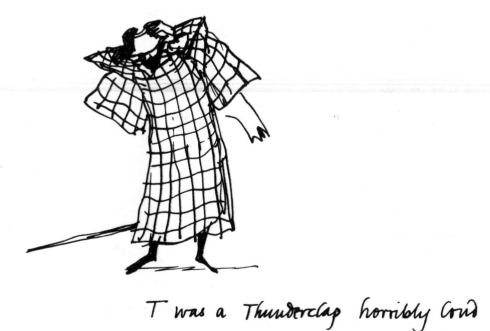

T was a Thunderclap horribly loud

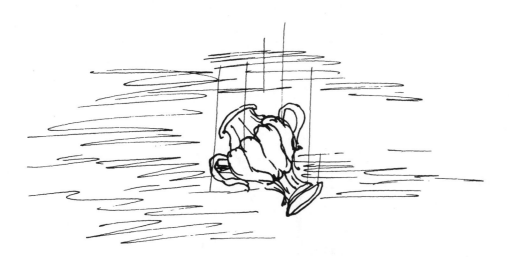

U was the Urn it dislodged from the sky

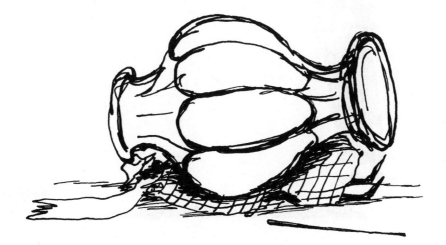

V was its Victim who cried out 'But why?'

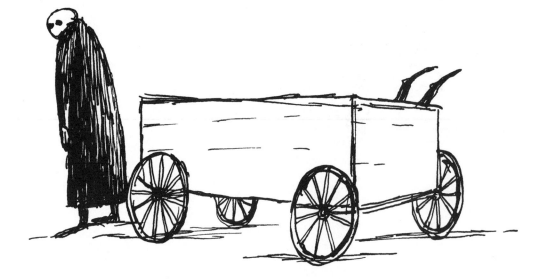

W was the Wagon in which his life ended

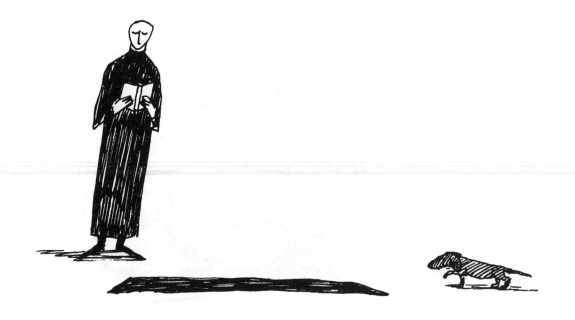

X was the Exequies sparsely attended

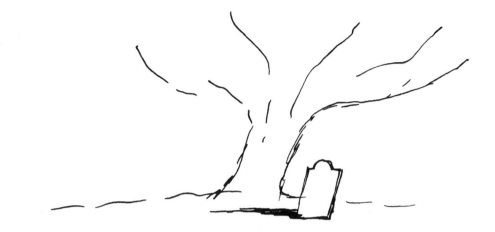

Y was the Yew under which he was laid

Z was the Zither he left to the maid

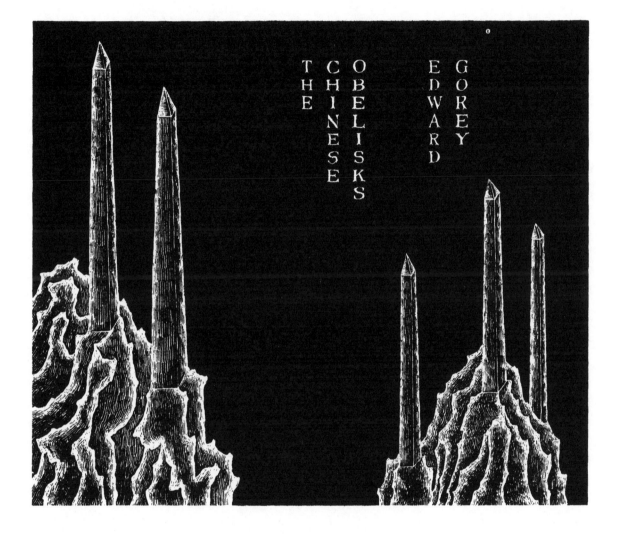

THE CHINESE OBELISKS EDWARD GOREY

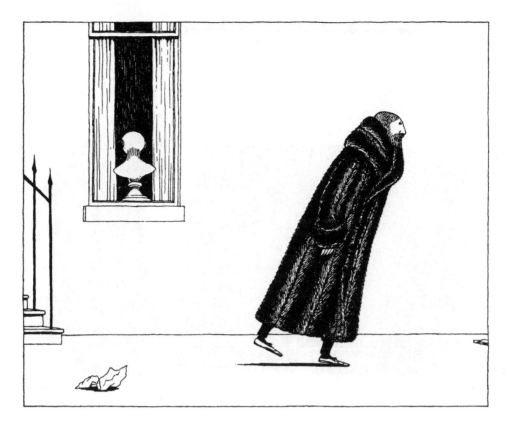

A was an Author who went for a walk

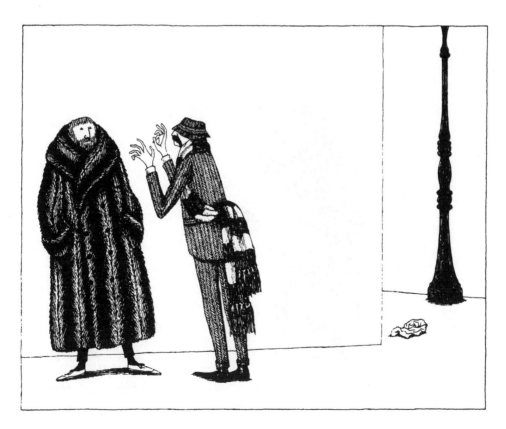

B was a Bore who engaged him in talk

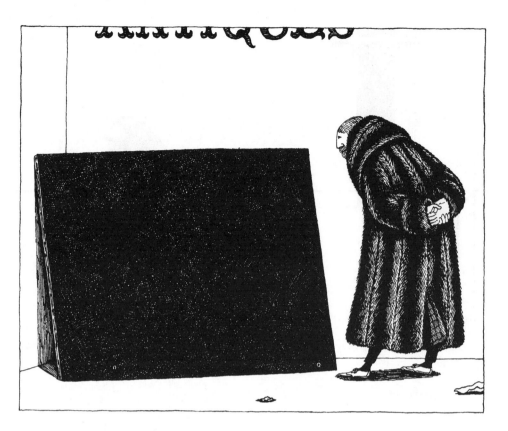

C was a Canvas encrusted with dirt

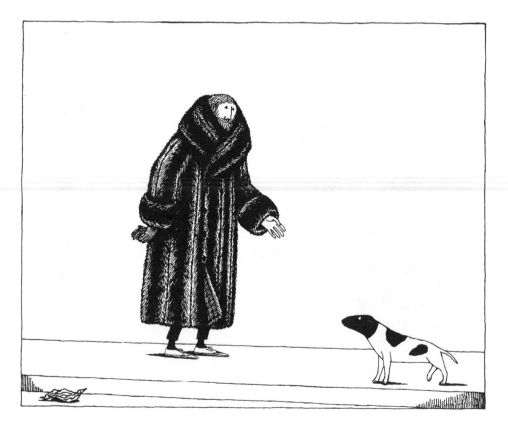

D was a Dog who appeared to be hurt

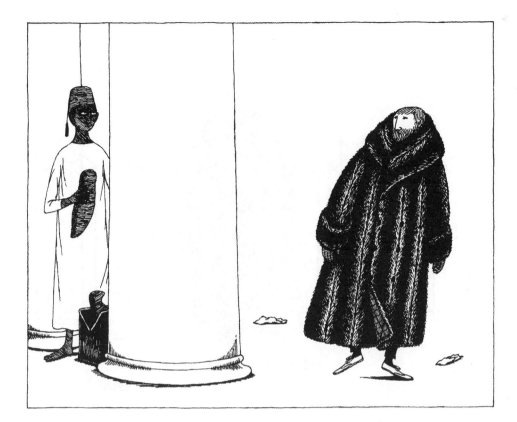

E an Egyptian with things from a tomb

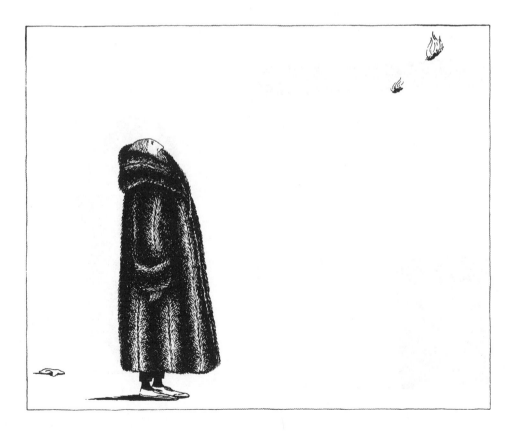

F was a Fire in a top-storey room

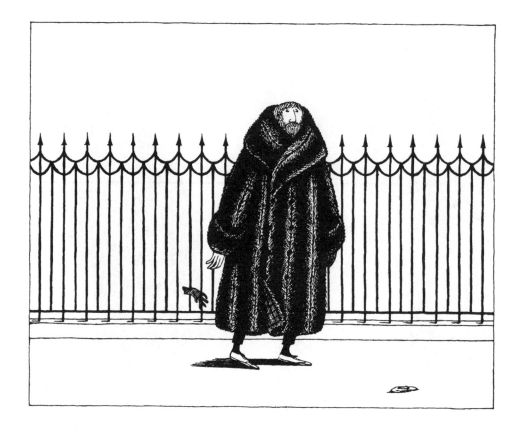

G was the Glove that he dropped without thinking

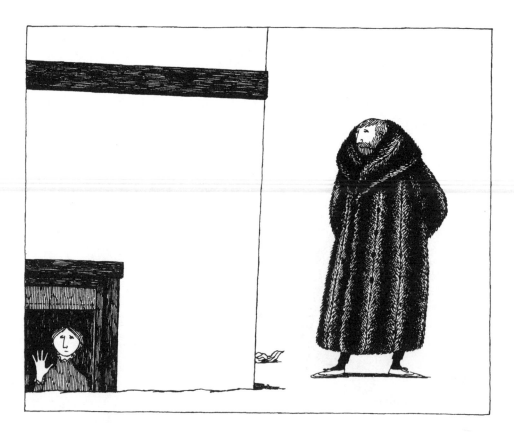

H was a House whose foundations were sinking

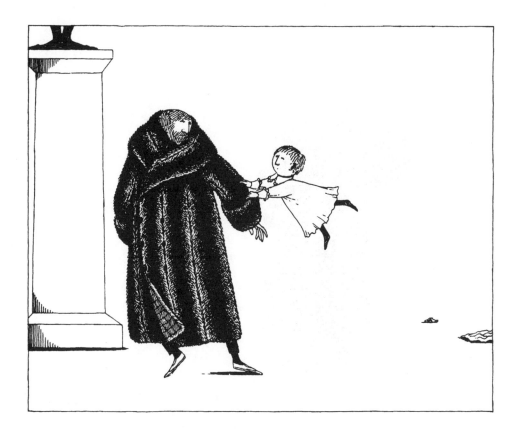

I was an Infant who clung to his sleeve

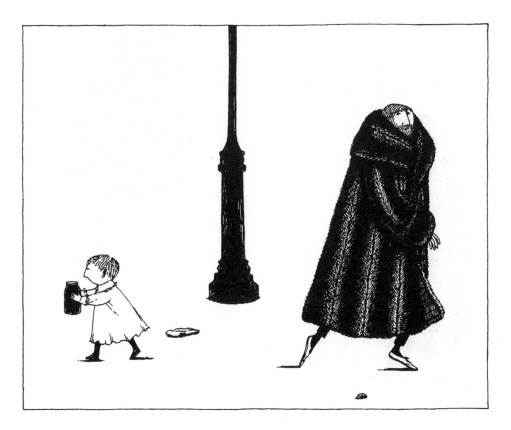

J was the Jam that he gave it to leave

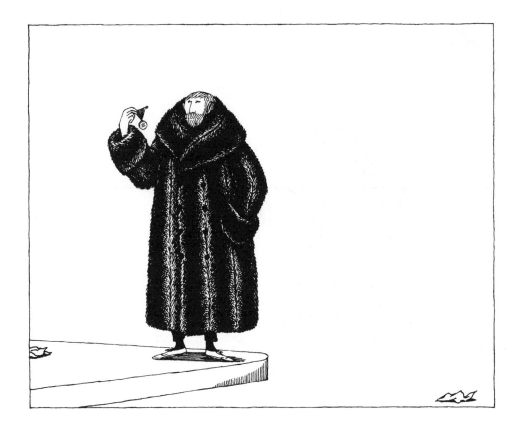

K was a Keepsake picked up from the gutter

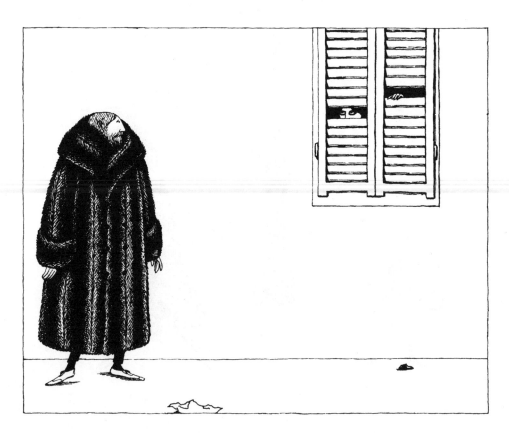

L was a Lady who peered through a shutter

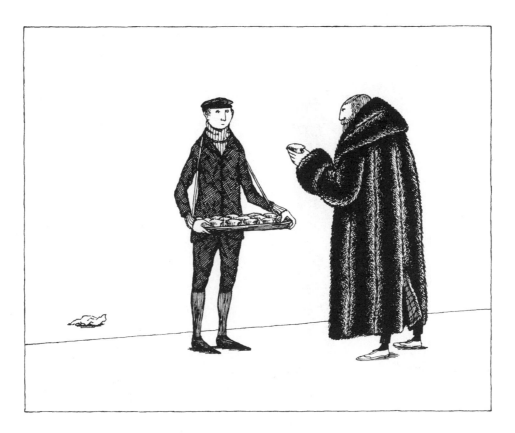

M was a Muffin he bought from a tray

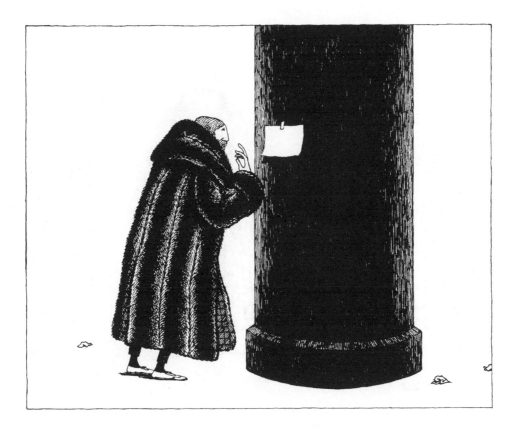

N was a Notice that caused him dismay

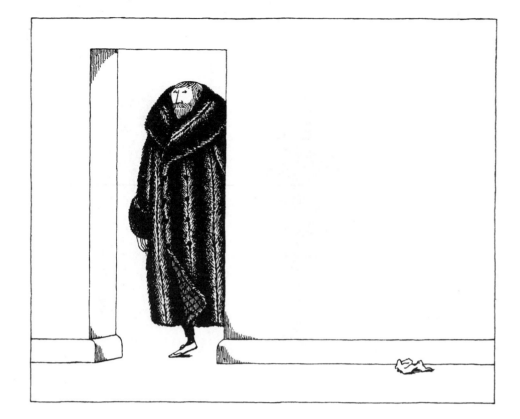

O was an Opening let in a wall

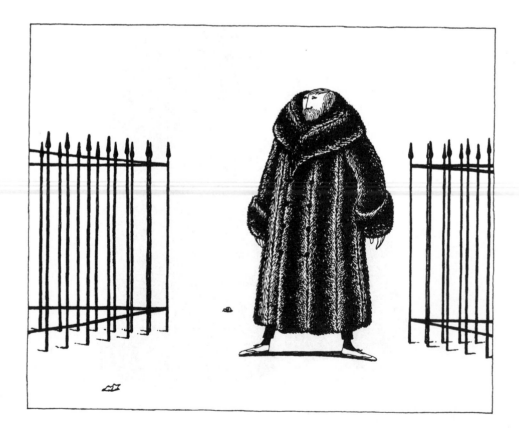

P was a Place he did not know at all

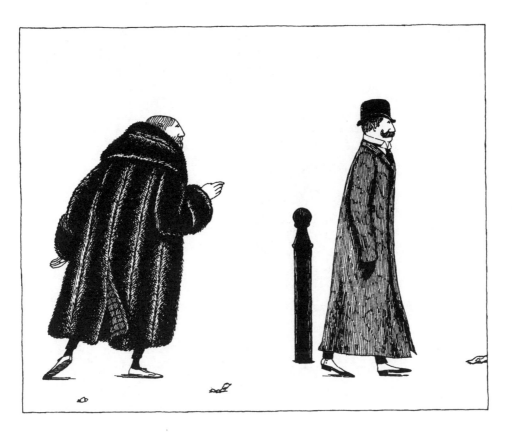

Q was the Question he asked of a stranger

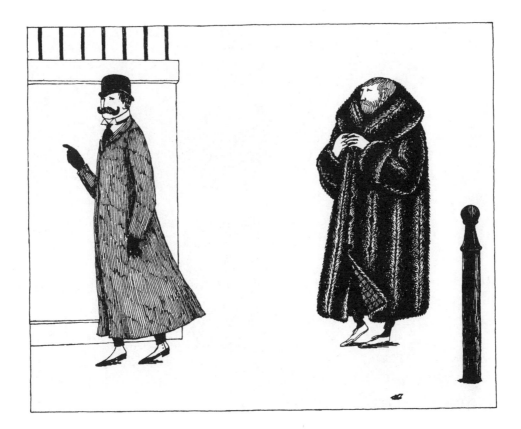

R the Reply that his life was in danger

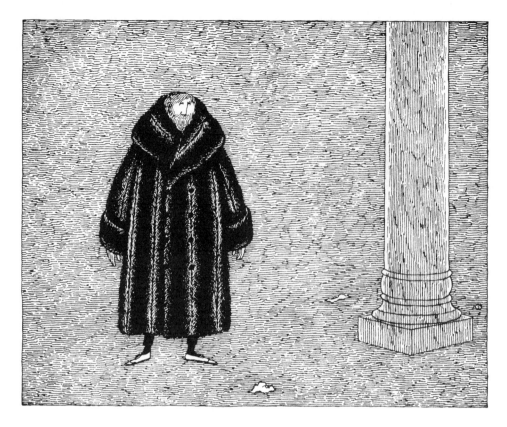

S was the Sun which went under a cloud

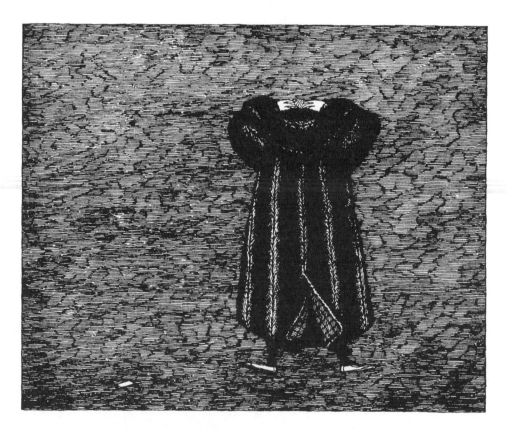

T was a Thunderclap horribly loud

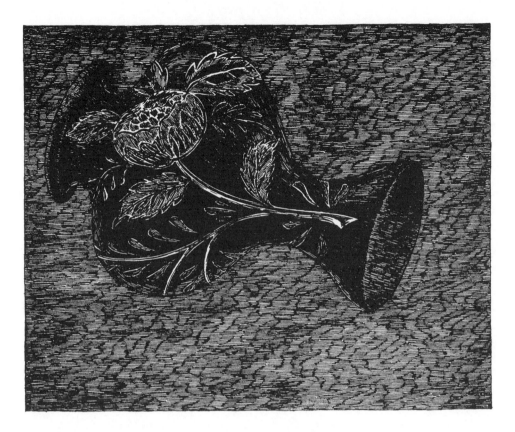

U was the Urn it dislodged from the sky

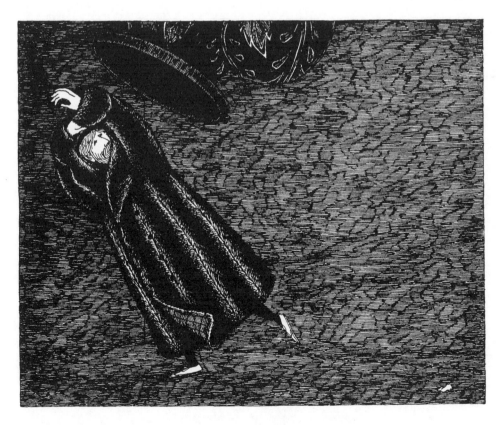

V was its Victim who cried out 'But why?'

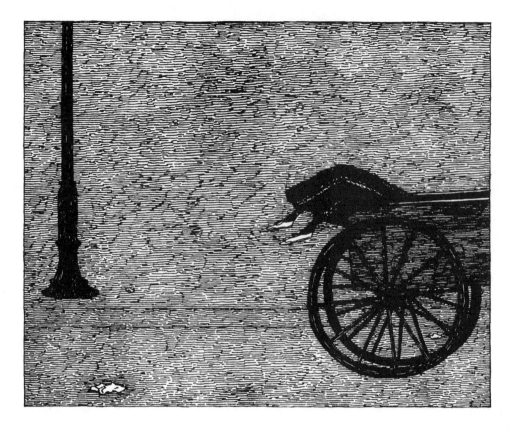

W was the Wagon in which his life ended

X was the Exequies sparsely attended

Y was the Yew beneath which he was laid

Z was the Zither he left to the maid

THE DERANGED COUSINS

BY EDWARD GOREY

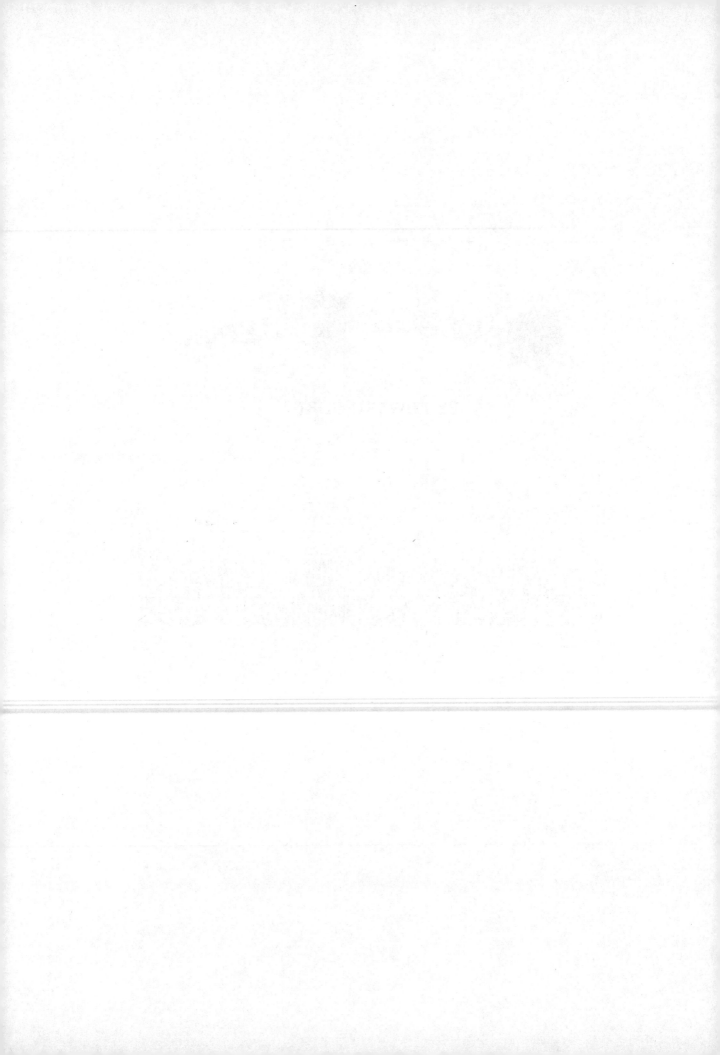

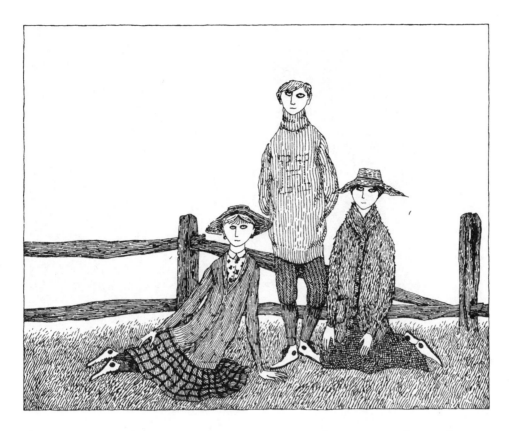

Seventy-nine years ago there were three cousins whose names were Rose Marshmary, Mary Rosemarsh, and Marsh Maryrose.

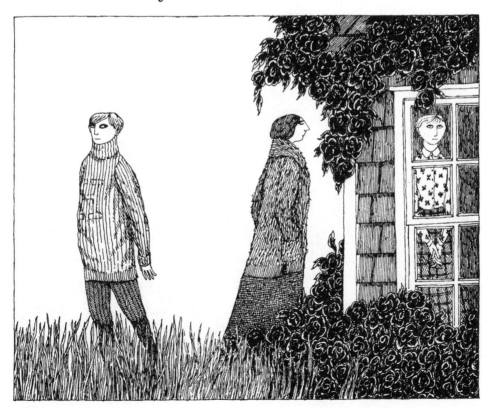

They lived in a house covered with roses on the edge of a marsh.

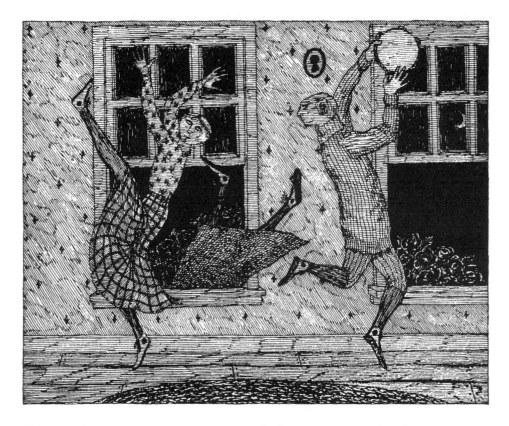

Since they were orphans and there was nobody to stop them, they were often merry far into the night.

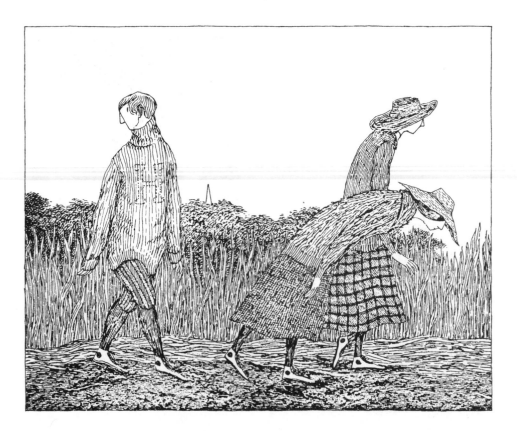

In the daytime they picked up things left by the tide.

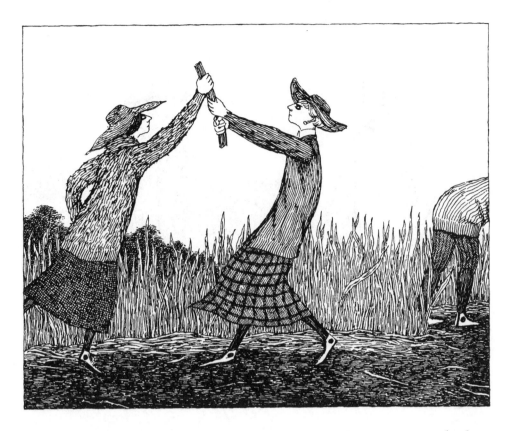

One September afternoon Rose and Mary quarreled
over a bedslat.

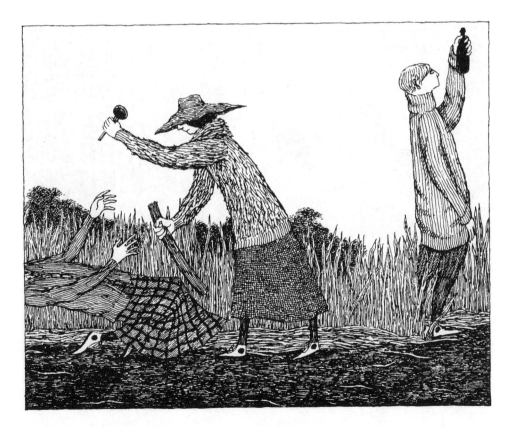

Mary struck Rose with a brown china doorknob
she had already found and killed her.

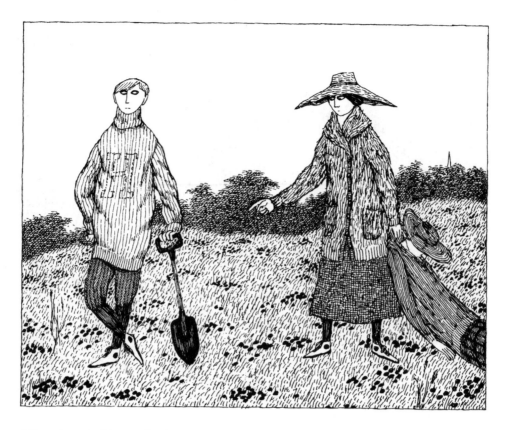

She had Marsh bury her in a field known as the
Rabbits' Restroom.

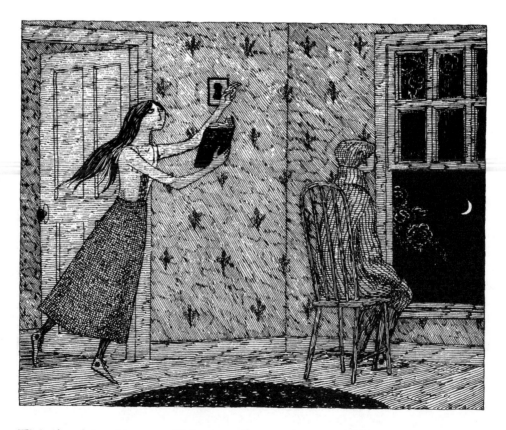

This incident caused her to become a religious maniac.

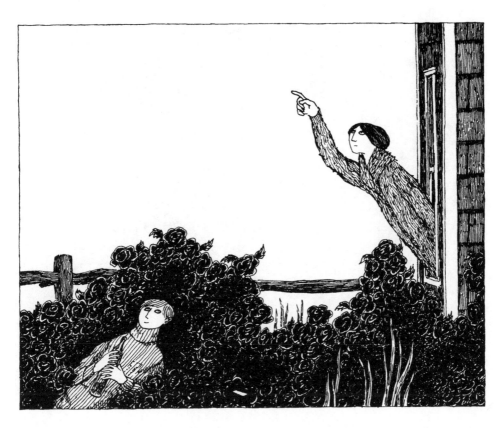

Shortly thereafter Marsh took to drink.

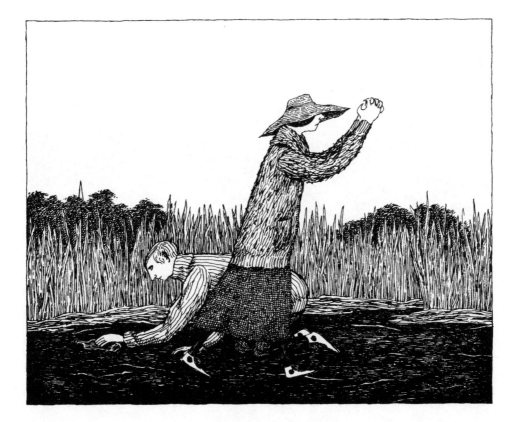

One April morning he drank the dregs of a bottle of vanilla extract he discovered in the mud.

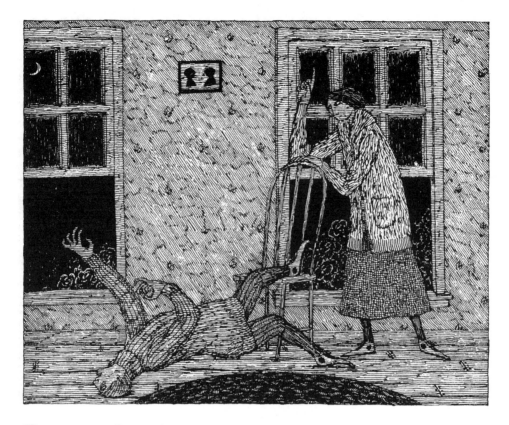

They must have been contaminated, for he died in agony during the night.

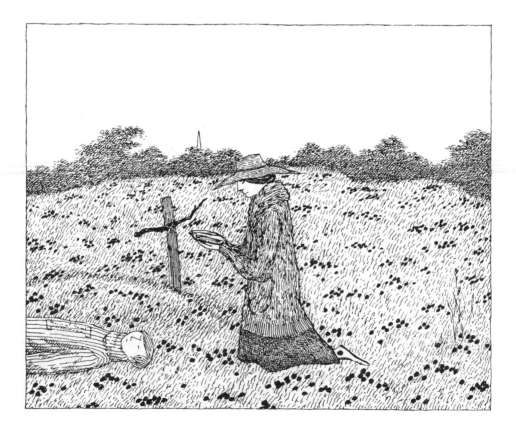

Mary conducted a funeral service by herself that lasted the whole day and then buried him near Rose.

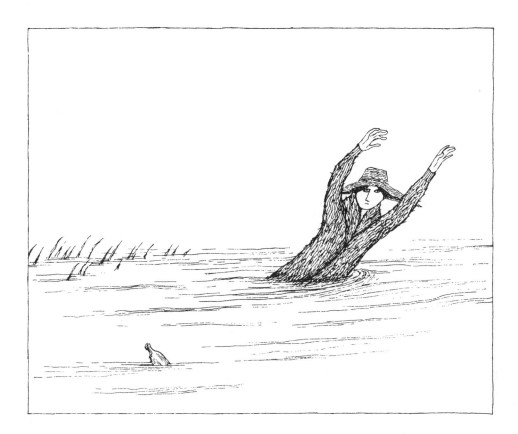

The next winter she was carried off by an unusually high tide.

They never found her body.

OR, WHATEVER

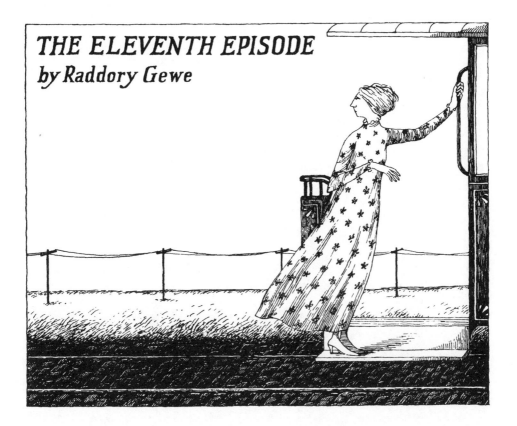

THE ELEVENTH EPISODE
by Raddory Gewe

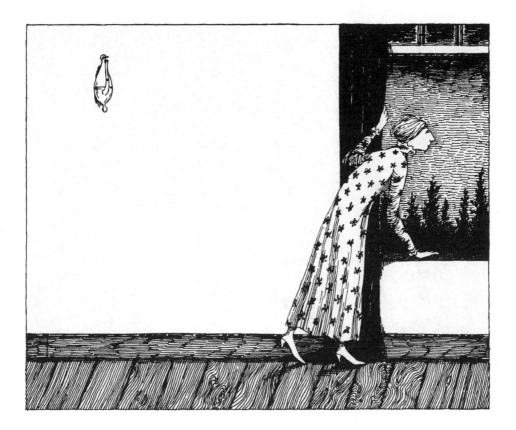

The window, which was open wide,
Let in a scream that rose outside.

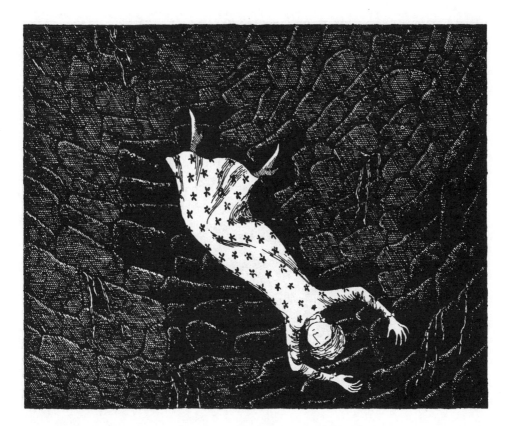

It came, she thought, from down the well;
She leaned too far and promptly fell.

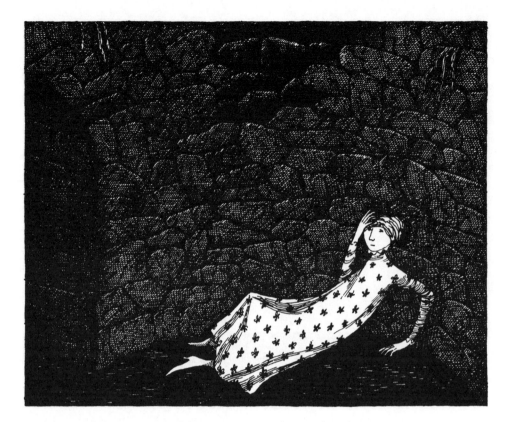

She knew no more until the thud
With which she landed on some mud.

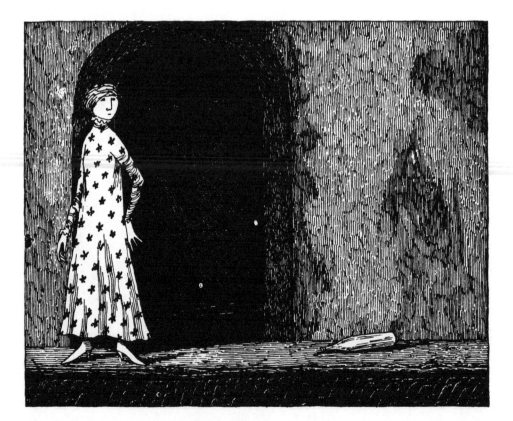

A disused tunnel at her feet
She followed to a sordid street.

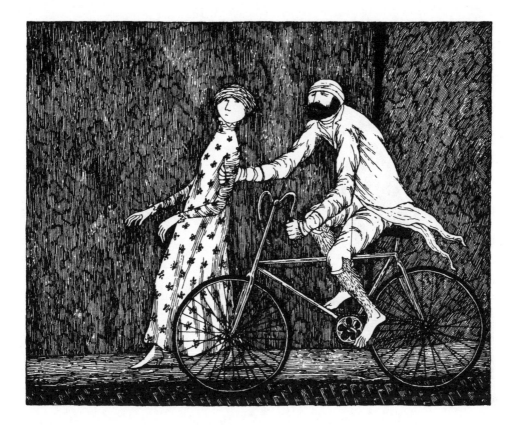

A passing cyclist seized her arm;
She felt that he intended harm.

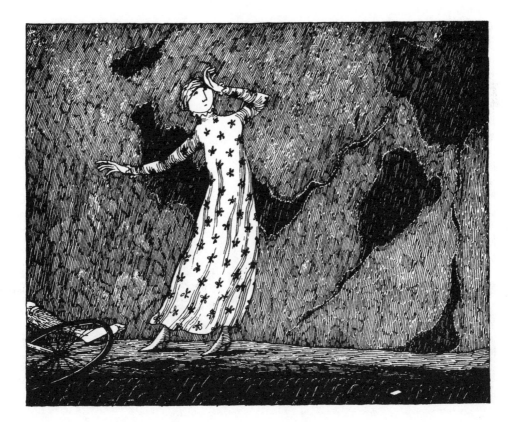

Her gown supplied her with a pin;
She chose a spot and stuck it in.

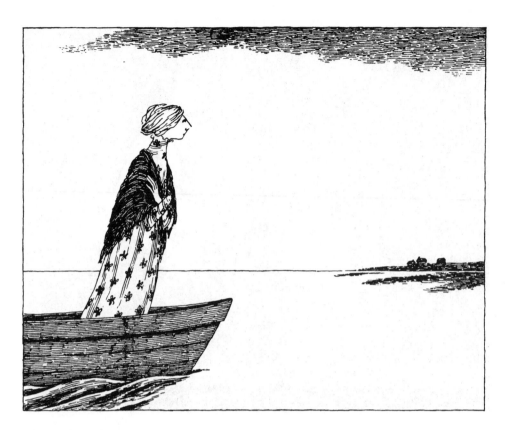

She fled by tram, then train and boat,
To places ever more remote.

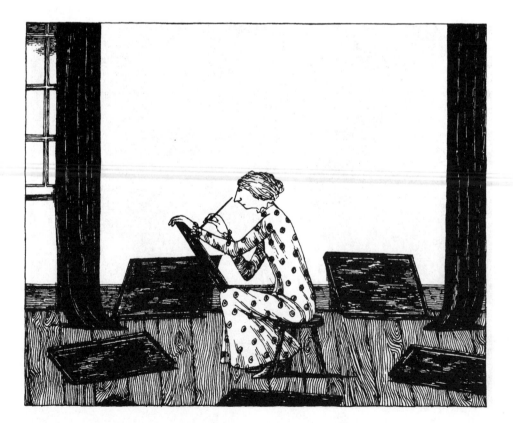

She changed her name and spent the days
In painting Scenes from Life on trays.

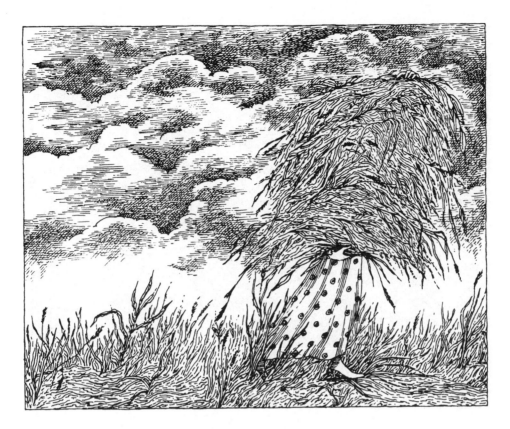

She cleared the garden of its weeds
And planted several thousand seeds.

Small creatures picked the flowers at dawn
And danced with them about the lawn.

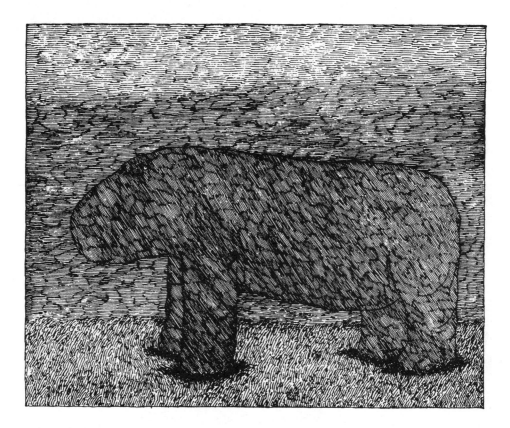

Until they all, down to the least,
Were eaten by a monstrous beast.

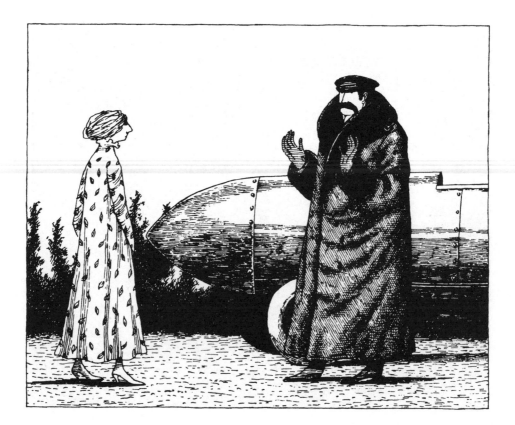

Next day a motorist drove up
And told her to expect a cup.

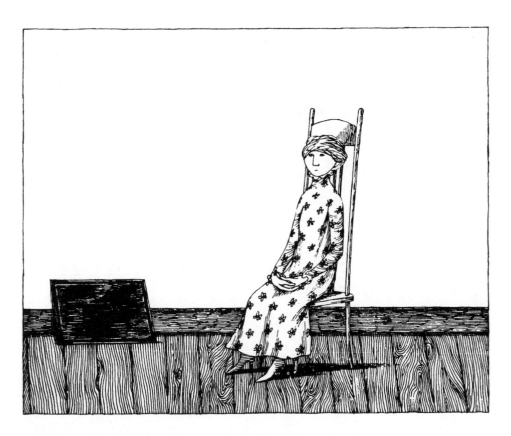

The weeks went by; no package came;
She did not know the sender's name.

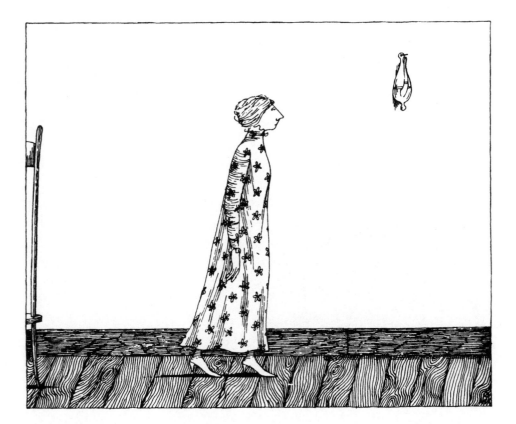

'Life is distracting and uncertain,'
She said and went to draw the curtain.

[The Untitled Book]

Hippity wippity,

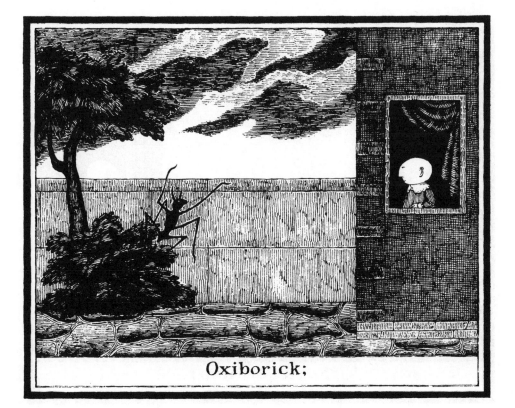

Oxiborick;

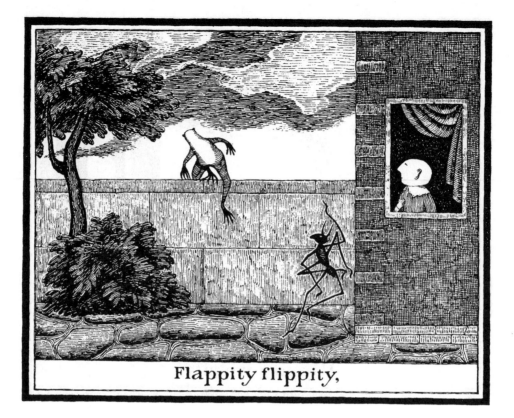

Flappity flippity,

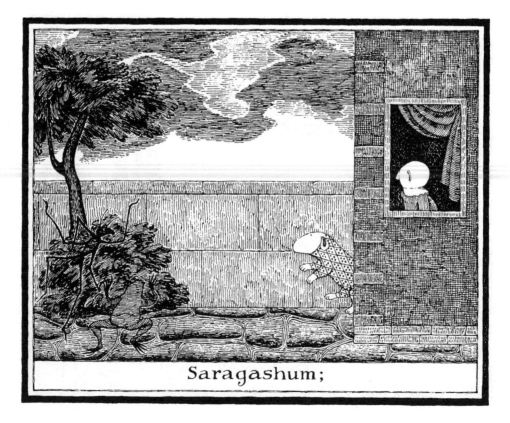

Saragashum;

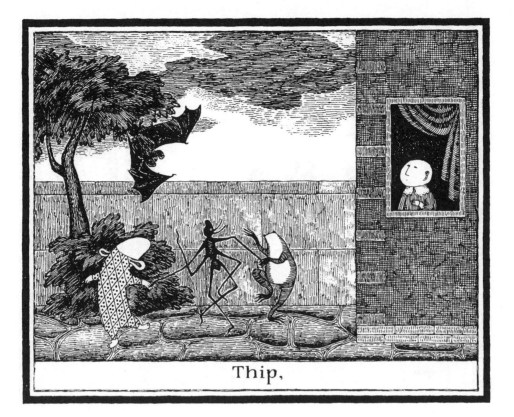

Thip,

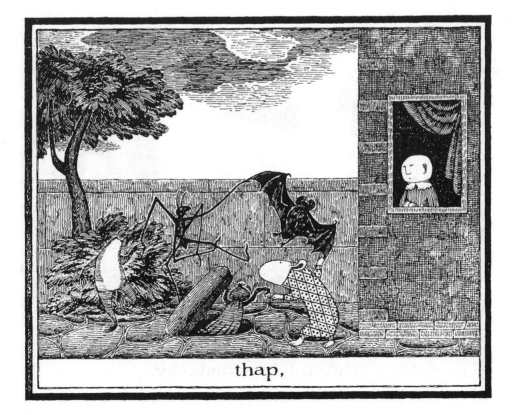

thap,

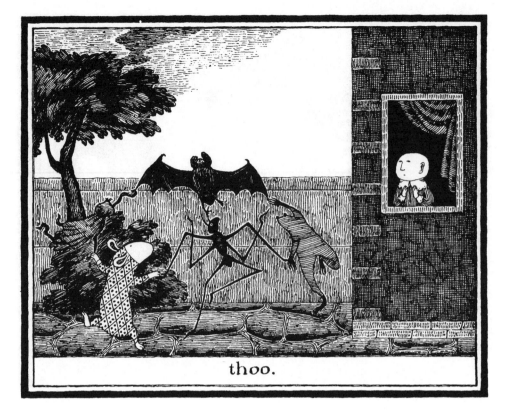

thoo.

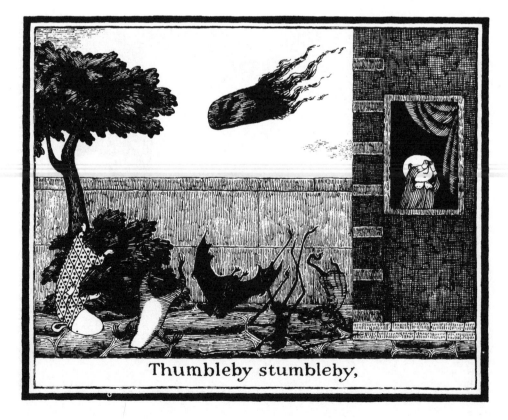

Thumbleby stumbleby,

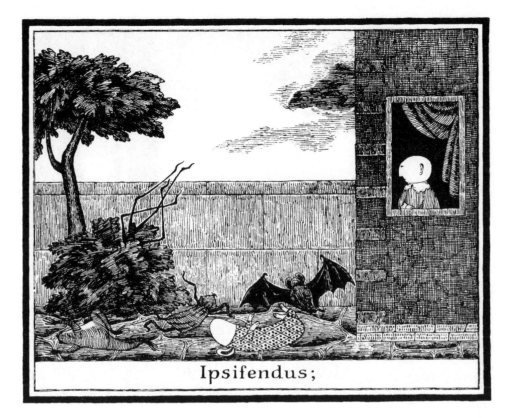

Ipsifendus;

Rambleby rumbleby,

Quoggenzocker;

Hip,

hop,

hoo.

by Edward Pig

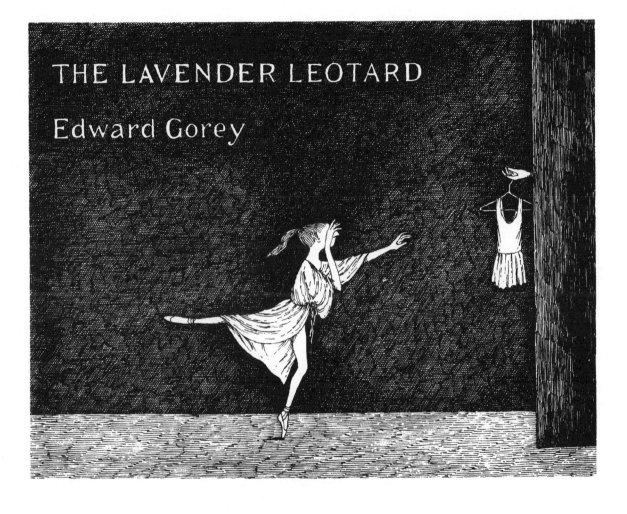

THE LAVENDER LEOTARD

Edward Gorey

The author introduces two small,
distant, ageless, and wholly
imaginary relatives to fifty
seasons of the New York City
Ballet.

You know what?
I forgot your feather.

I warned you not to get
them tickets before row R.

One of us is no longer with the music.

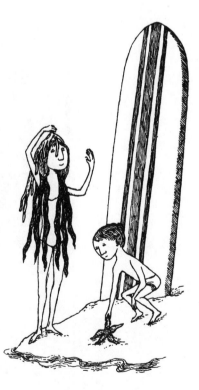

I can hardly wait for the fall
season, can you?

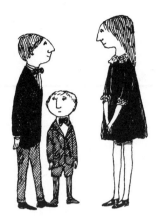

I thought we'd break him in on
*Swan-Lake-Firebird-Afternoon-of-
a-Faun-and-Western-Symphony.*

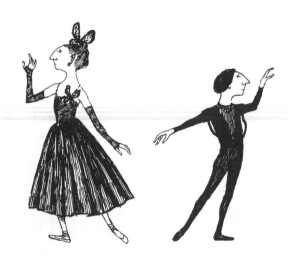

Now we lose one another hopelessly
among eight members of the corps.

You can be Benno, the Prince's Friend,
and catch me just before I hit
the floor.

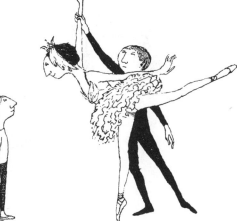

I suppose wearing only one
somehow makes me more so.

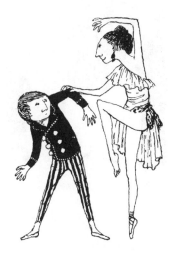

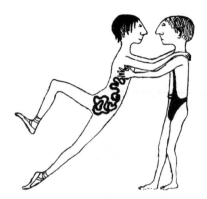

Just once we could use the *Serenade* costumes and the backdrop from *Lilac Garden*.

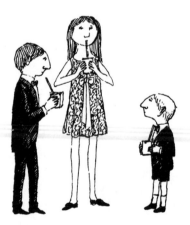

You're right, that was *Glinka* they were doing, but *Minkus* he was wearing.

You've given me the wrong one.

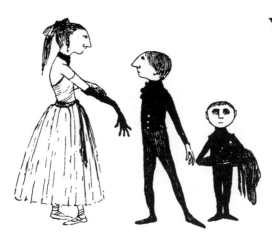

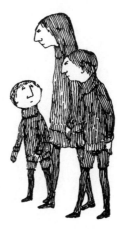

You clapped far too much; the company
really doesn't approve of curtain calls.

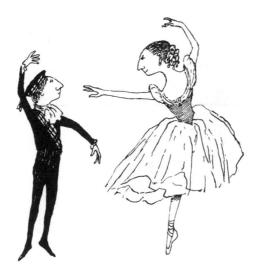

I think it would be more amusing
if they threw *you* at me.

There are twenty-seven *Swan Lakes* this
season, but only twenty-one *Firebirds*.

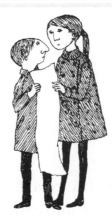

I wonder if I could make it into the
wings before the curtain comes down.

Don't you feel the whole idea of
sets and costumes is vulgar?

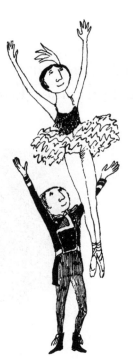

I'm Ike, you're Mamie.

Lilac Garden again; those are the side pieces,
and the bit across the middle must be the
edge of Swan Lake.

In my mind's eye I've always known
what it would have been like.

Let's see—he didn't do his first variation, and she didn't do her
second one; Barbara did the fifth instead of the fourth, and
Carol substituted for Linda, and Susan wasn't there at
all, but then who was...?

I didn't recognize you for a moment.

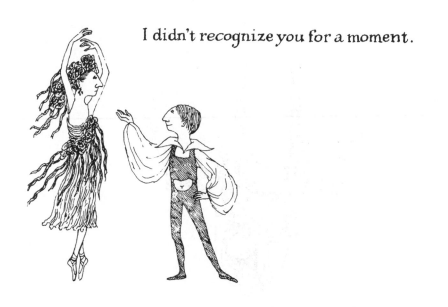

I made it myself out of a hundred
and thirty-two keychains.

No, you can't be Benno, the Prince's
Friend; he doesn't exist anymore.

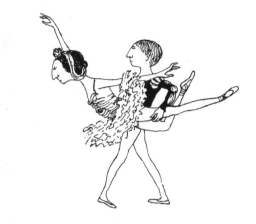

There are photographs of George
and Lincoln in the brooches on
their bodices.

I can't imagine now why this
ever seemed so difficult.

I sometimes think if I see that lavender
leotard with the little skirt that doesn't
quite match in one more ballet...

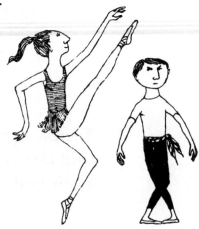

Are you sure this is only the
second time they've played it?

Other companies merely put
on ballets; we dance.

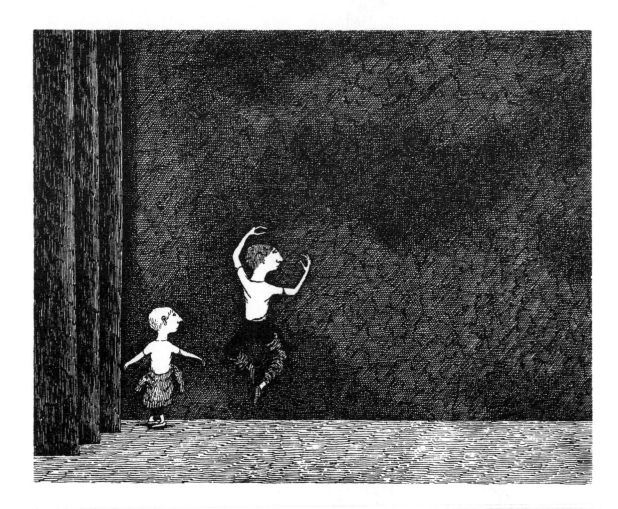

THE
Disrespectful
Summons

EDWARD GOREY

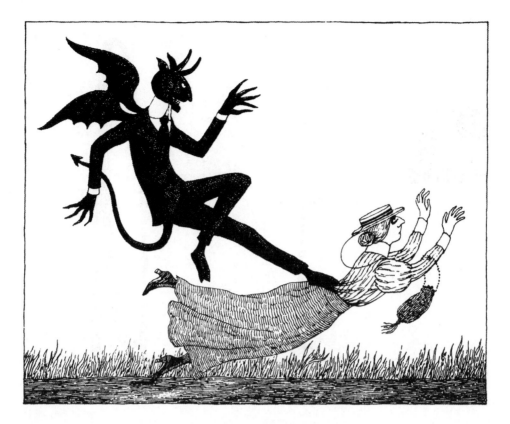

The Devil gave a sudden leap
And struck Miss Squill all of a heap.

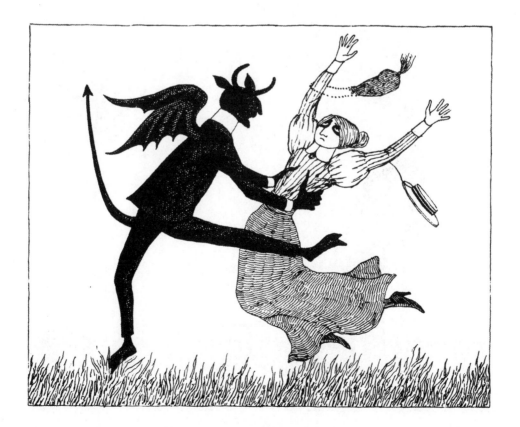

He swooped her up from off the ground
And twirled her madly round and round.

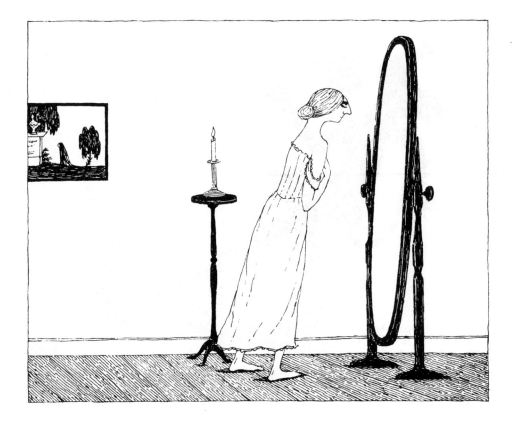

That night she saw when she undressed
His mark was burned upon her breast.

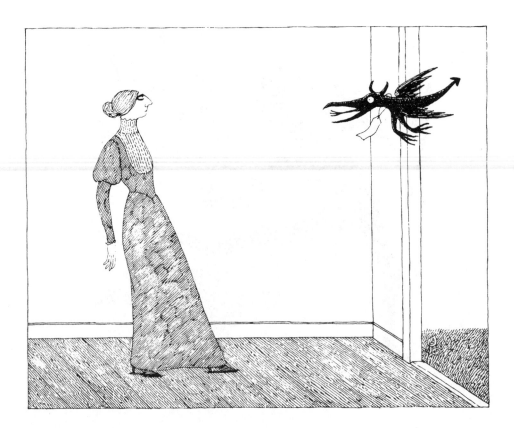

Next day flew in her open door
A creature named Beëlphazoar.

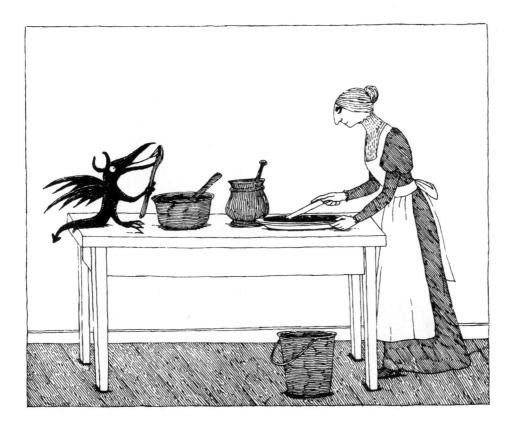

It brought a recipe for fudge
Of pounded pencil-stubs and sludge.

Also a book called *Ninety-two*
Entirely Evil Things To Do.

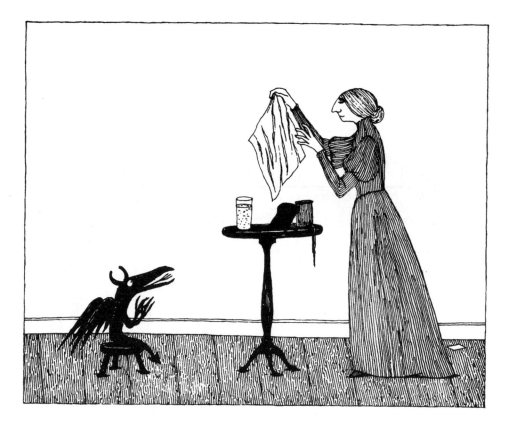

She cindered toast and rotted silk,
Corroded tin and curdled milk.

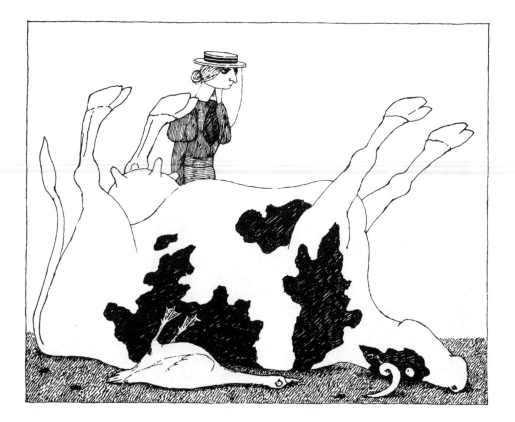

Her laugh made beetles swoon; her frown
Made geese and cows turn upside down.

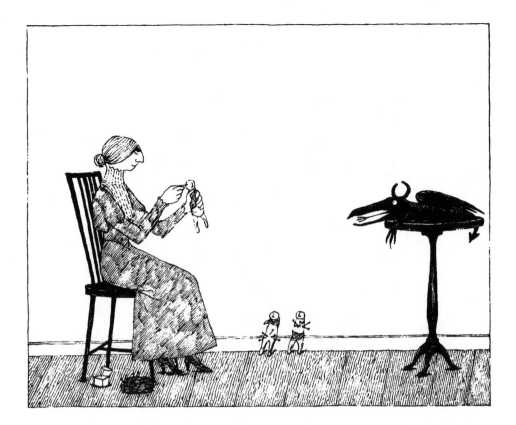

She did her neighbours' forms in wax
And stuck them full of pins and tacks.

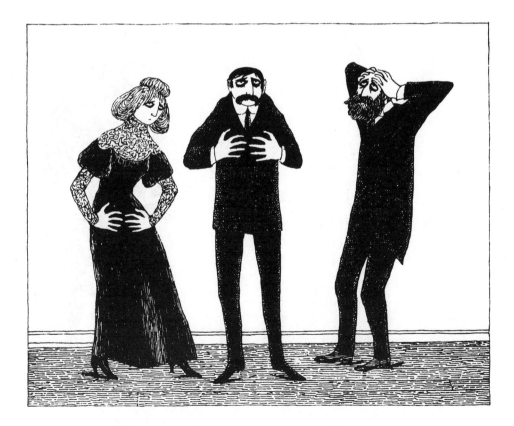

They then expired with frightful pains
Inside their bowels, lungs, and brains.

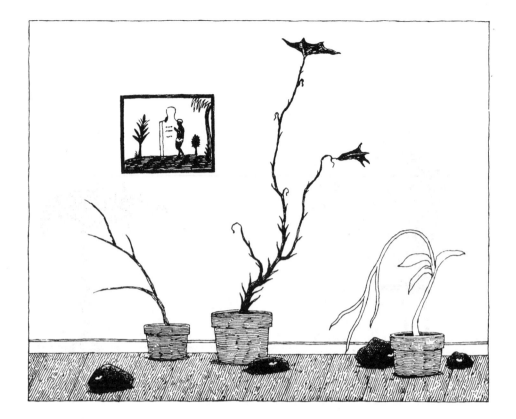

She got from somewhere stones with eyes
And plants that gave out screams and sighs.

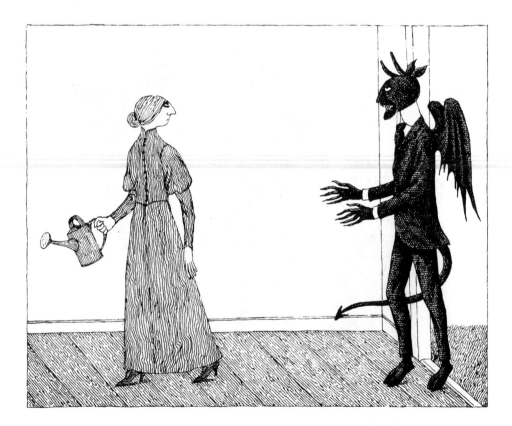

But then the demon, much too soon,
Returned one Sunday afternoon.

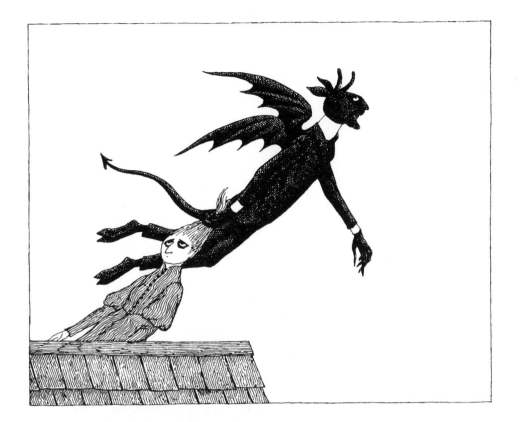

He seized her hair, and with his hoof
He kicked a way *out* through the roof.

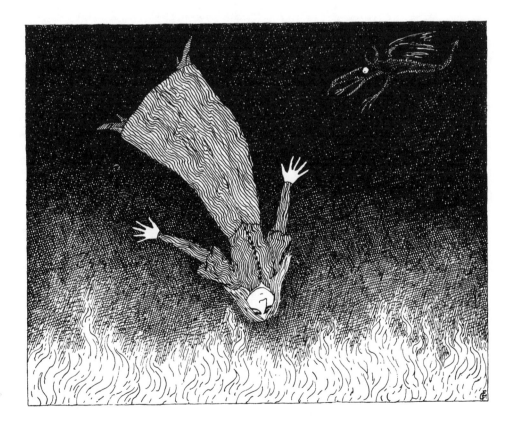

The end had come, and this was it;
He dropped her in the Flaming Pit.

EDWARD GOREY

THE

ABANDONED

SOCK

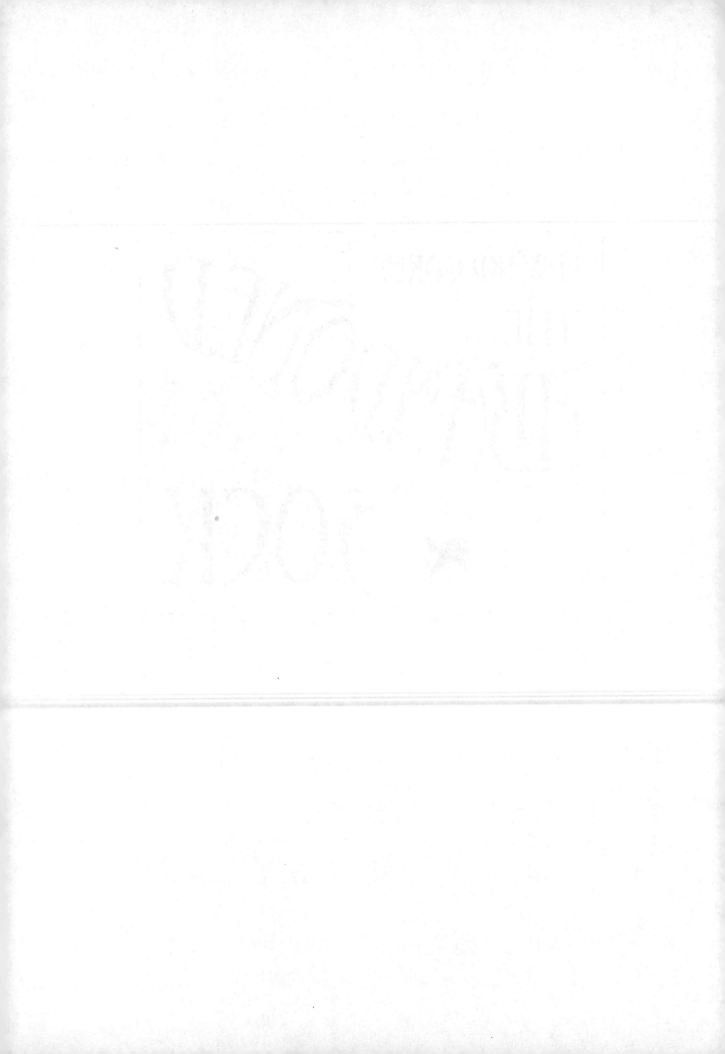

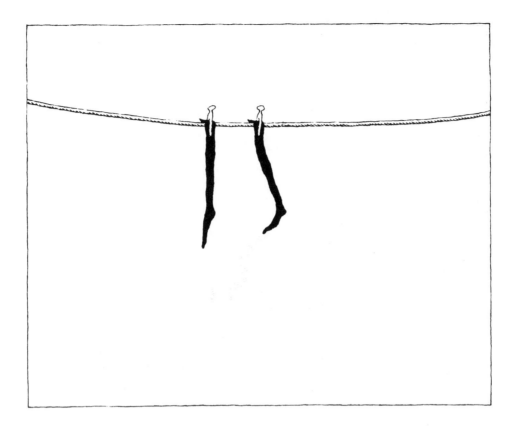

One summer morning a sock on the line decided that life
with its mate was tedious and unpleasant.

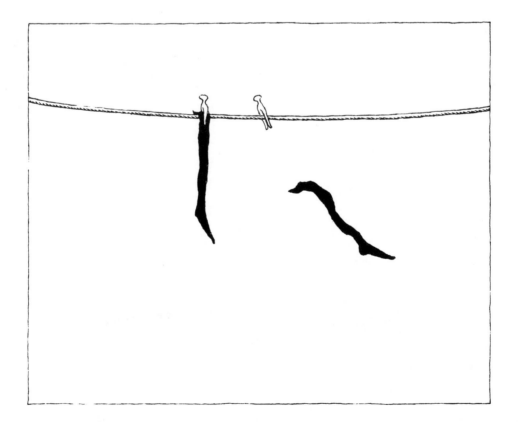

It persuaded the clothespin to relinquish its hold, and
blew away on the next breeze.

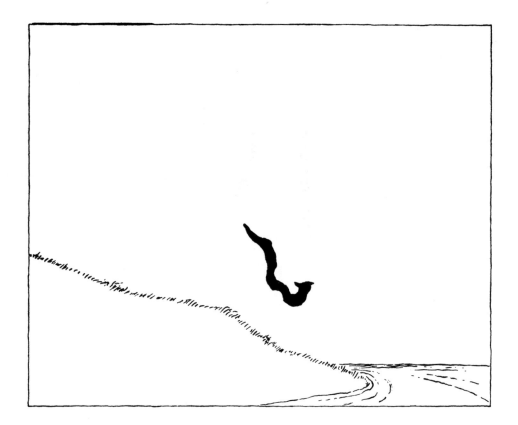

It tumbled over the grass, down a bank, and into the river.

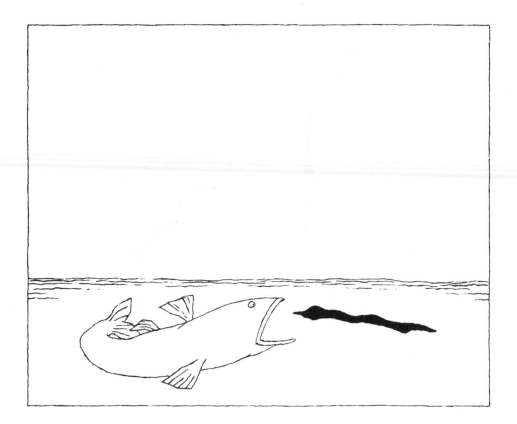

As it was being carried towards the sea, a large fish considered swallowing it, but changed its mind.

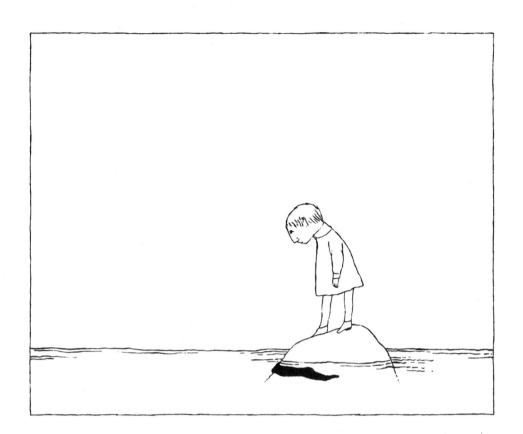

At dusk it caught against a rock where it remained until a child found and wrung it out the next morning.

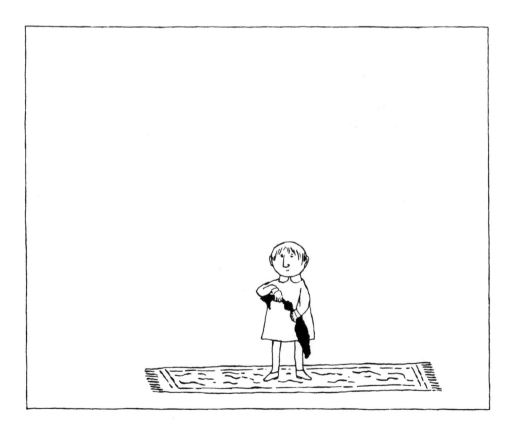

The child filled its toe with dirty pennies and then tied a knot in it which was extremely painful.

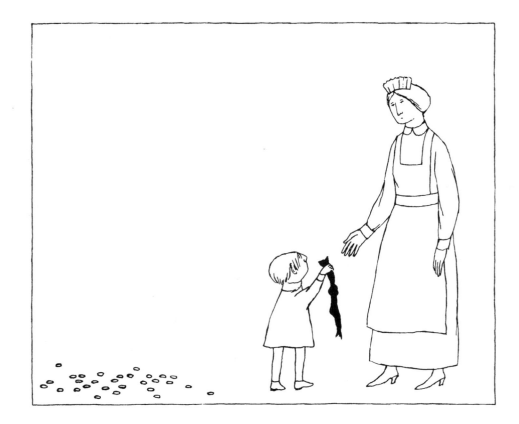

After the pennies fell out through the hole they'd worn in the toe, the child let the maid have it.

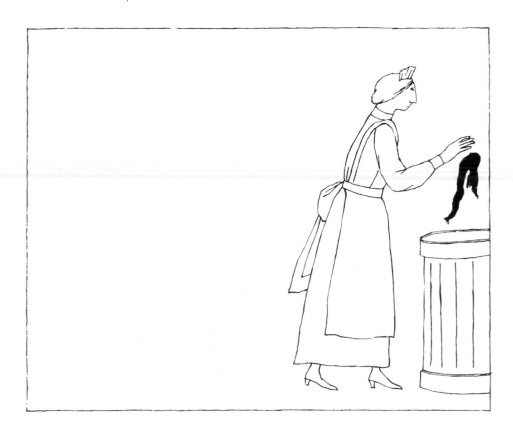

At last it was no use even for wiping furniture with, so she threw it in the dustbin.

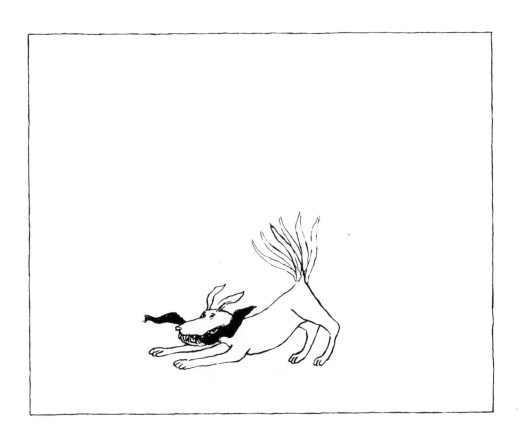

A dog took it out again and worried it terribly.

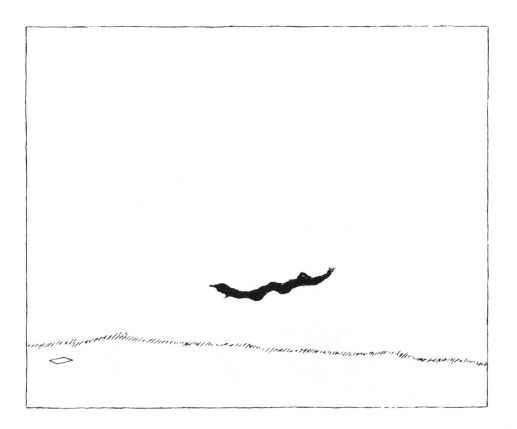

When the dog went off to its dinner, a gust of wind
picked it up.

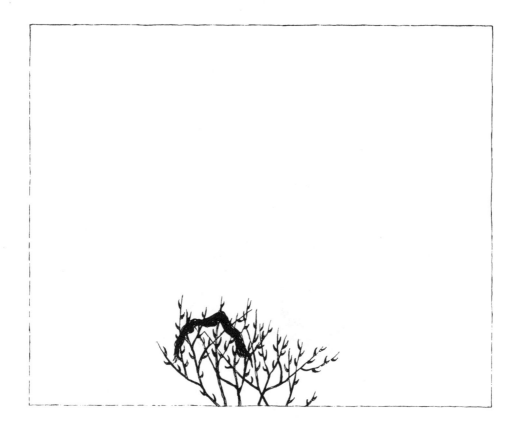

After *crossing* over several fields it landed inextricably in
a thorn bush.

Rain fell frequently, then snow.

With spring birds came and took bits of it for their nests.

By the end of summer nothing was left of the sock to speak of.

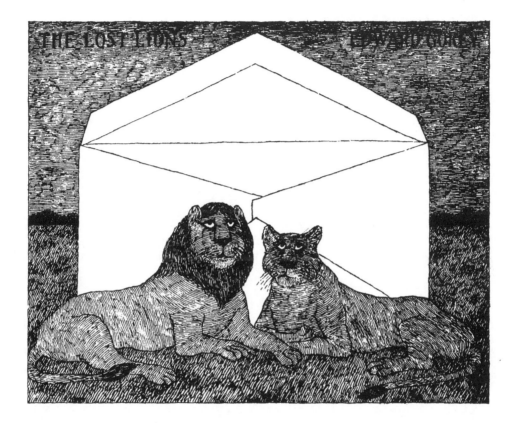

Hamish was a beautiful young man who liked being out of doors.

When he wasn't outdoors he kept a voluminous diary.

One day he opened the wrong envelope.

He thus went on the films, in which he was almost always out of doors.

With his sudden wealth he bought a stylish house in extensive grounds, and began to raise lions.

Soon he was being mobbed by people in the street.

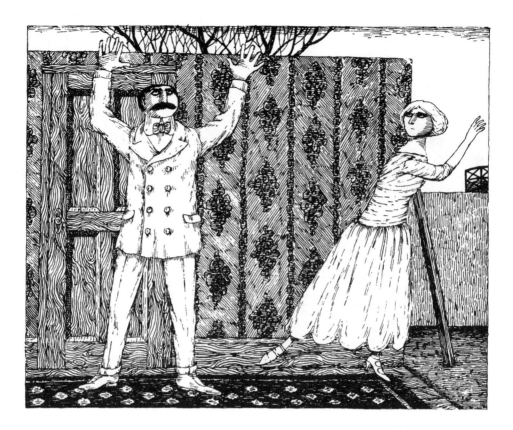

One day at the studio he became overstrung.

After that he fled to South America, where he was outdoors all the time.

He returned **several years later**, although not to films.

He devoted himself to raising more lions and working at his diaries.

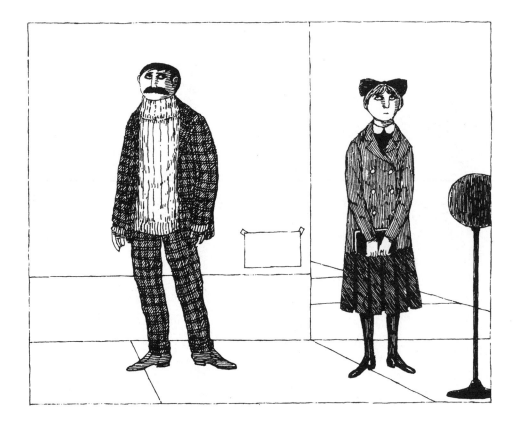

At last people no longer mobbed him in the street.

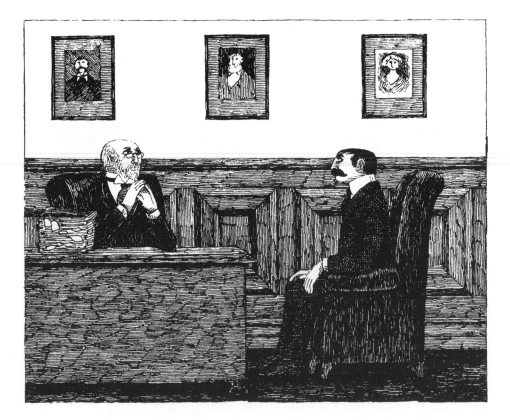

He made a trip to New York because a publisher was
thinking of bringing out parts of his diary.

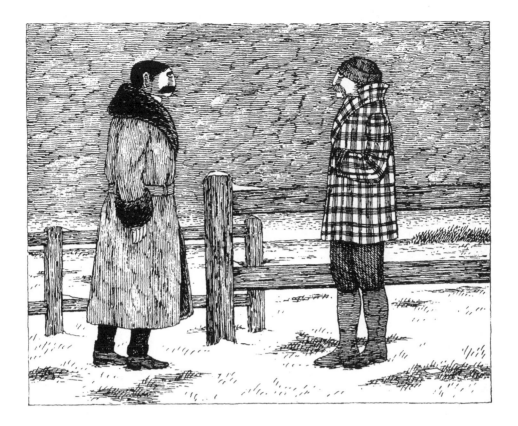

He drove to a farm in New Jersey where a pair of his
lions were.

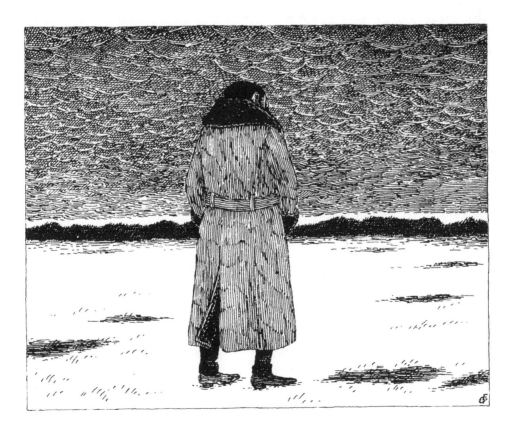

He was told they had been sent to Ohio for the winter.

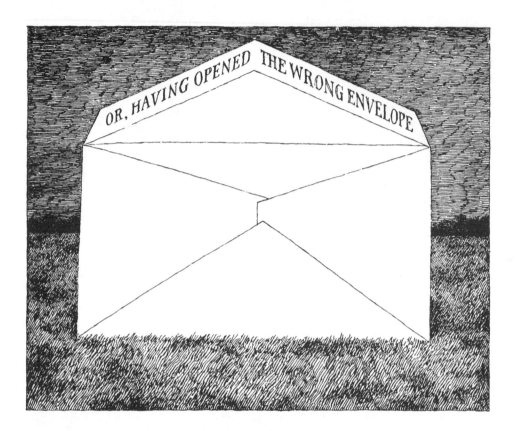

STORY FOR SARA
Alphonse Allais

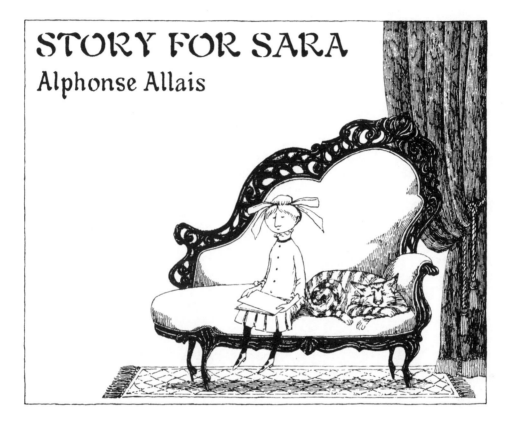

Once upon a time a little girl was going to take her doll for a walk when there she was, meeting two nice little birds.

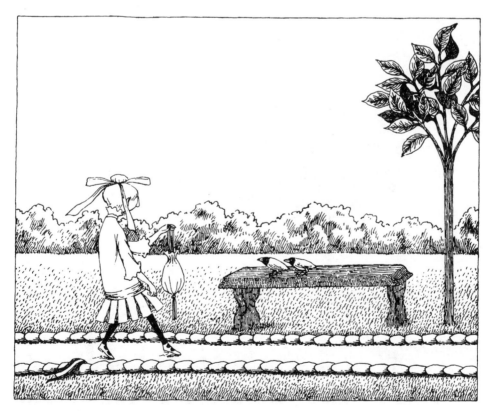

She dropped them a pretty little curtsy and said to them: 'Good afternoon, little birds. Will you play with me? I have *some* lovely comfits in my little bag; I'll give you some.' One of the little birds said: 'I have no objection,' and the other one said: 'Neither do I.'

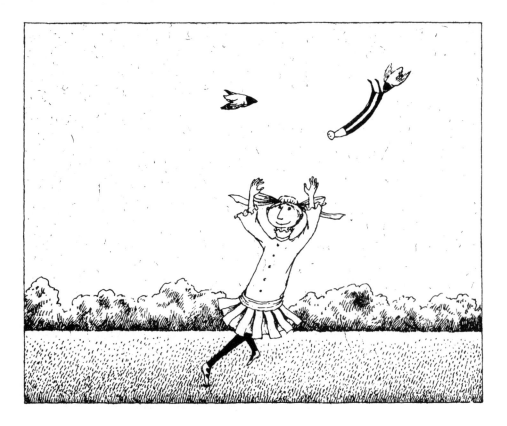

They enjoyed themselves very much until it was
nearly evening;

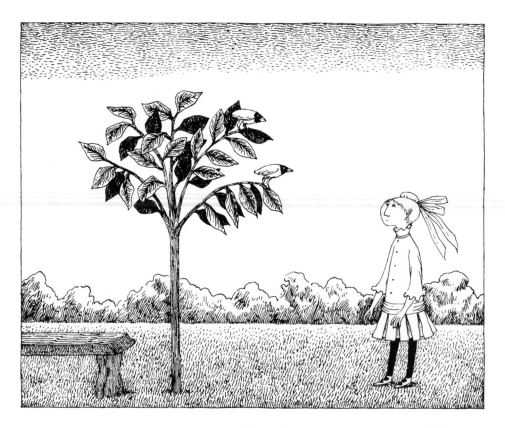

then the little birds said: 'We want to go away now.

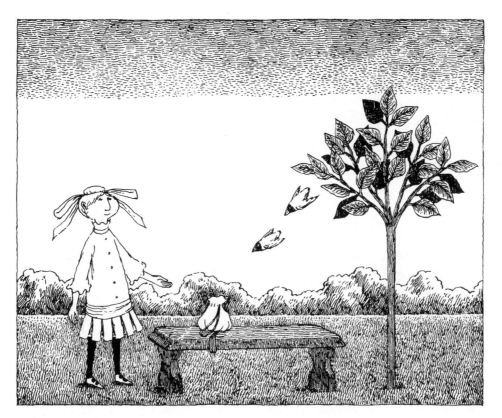

But along with the coming night a wicked thought came to the little girl. She said to the little birds: 'I still have some comfits at the bottom of my little bag. Come and fetch them if you like.'

They came at once and before you could say knife, she pulled the strings tight, and the little birds were caught.

They chirped and chirped in vain: the little girl
carried them off.

That evening, wouldn't you know, there was a large cat
prowling in the neighbourhood. He came running
full tilt on hearing the little birds chirp.

When the little girl saw him, she dropped him her most beautiful curtsy—the one her grown-up cousin had taught her—and said to him: 'Good evening, Mr cat.' The cat said nothing at all.

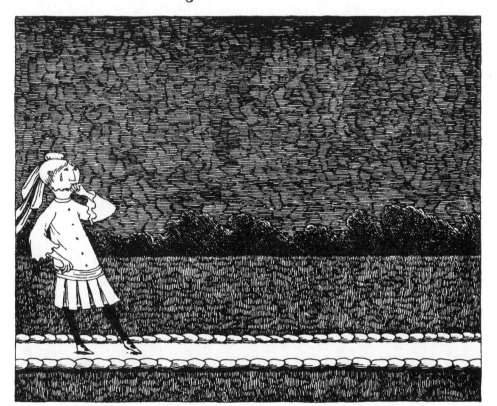

The little girl took fright at seeing this great beast who was coming towards her with such enormous eyes and such a huge mouth; she took fright and began to cry.

The cat didn't care a bit; he swallowed her in one mouthful (it was jolly well done).

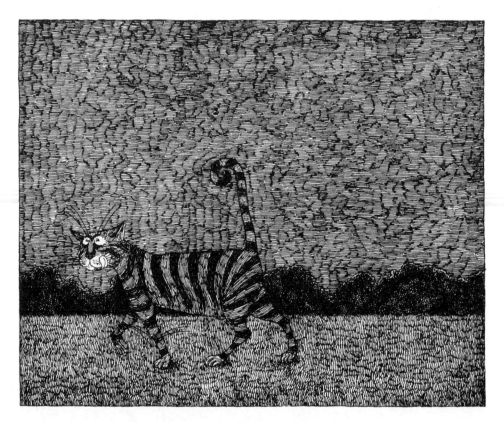

He went off contentedly licking his chops,

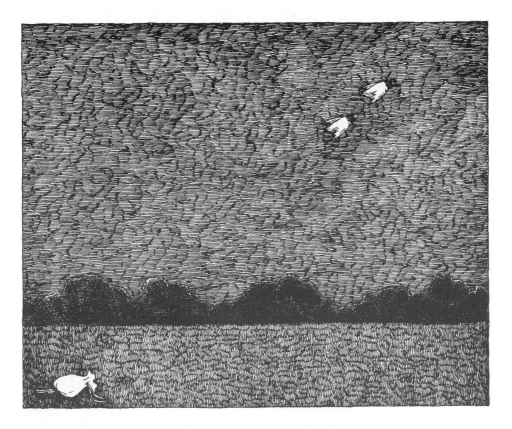

while for their part the little birds, whom he hadn't even noticed, flew away as fast as they could;

and that's all.

He came along holding in his hands dirty, dirty, dirty,

A big nail pointed, pointed, pointed,

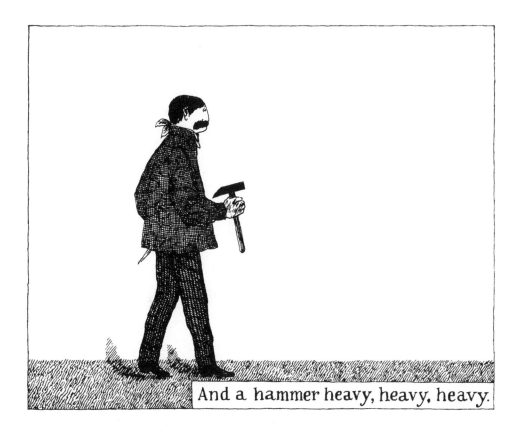

And a hammer heavy, heavy, heavy.

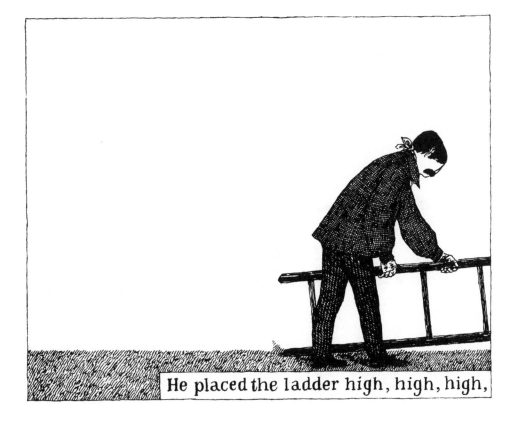

He placed the ladder high, high, high,

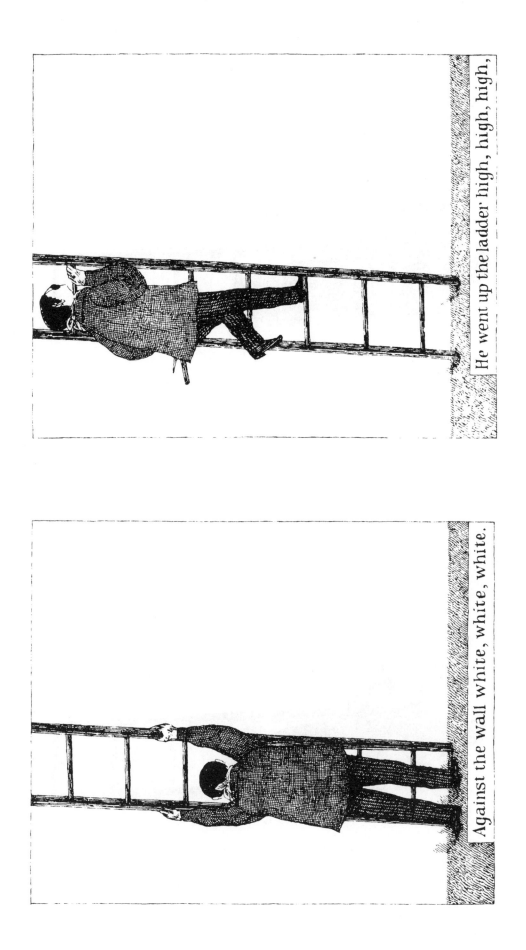

He went up the ladder high, high, high,

Against the wall white, white, white.

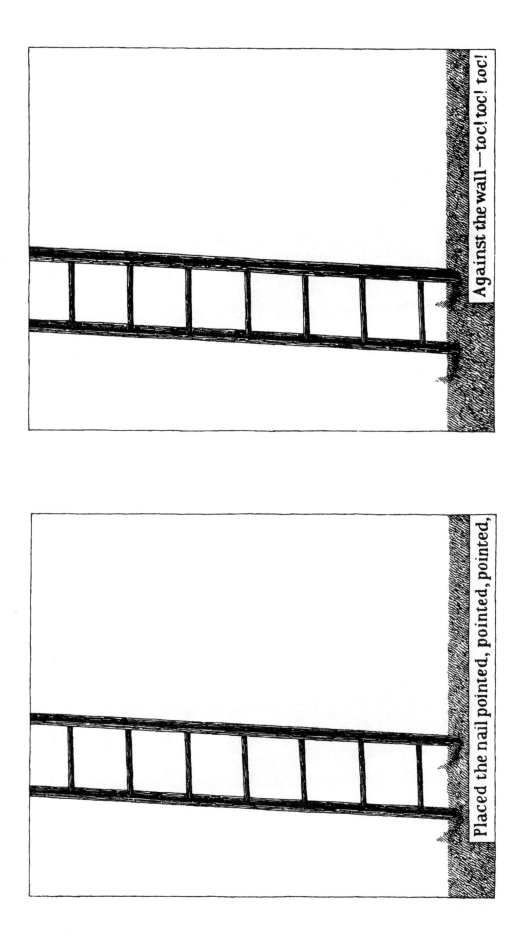

Placed the nail pointed, pointed, pointed,

Against the wall —toc! toc! toc!

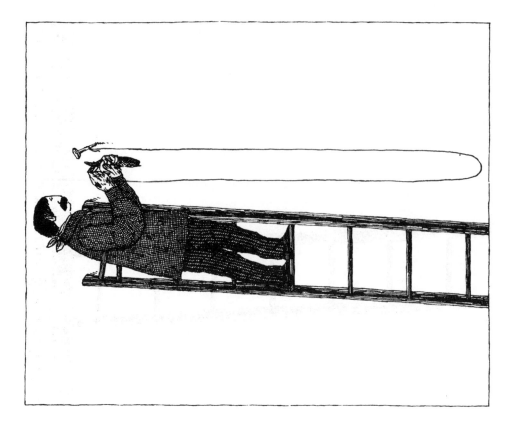

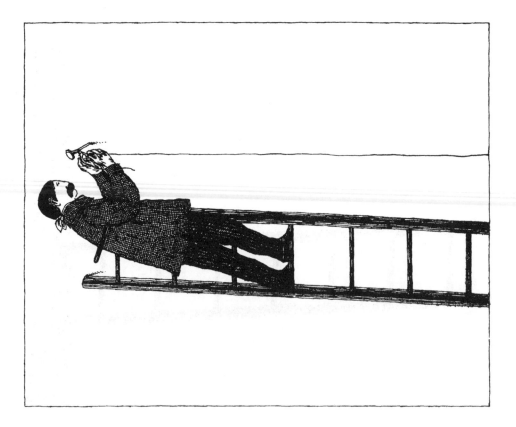

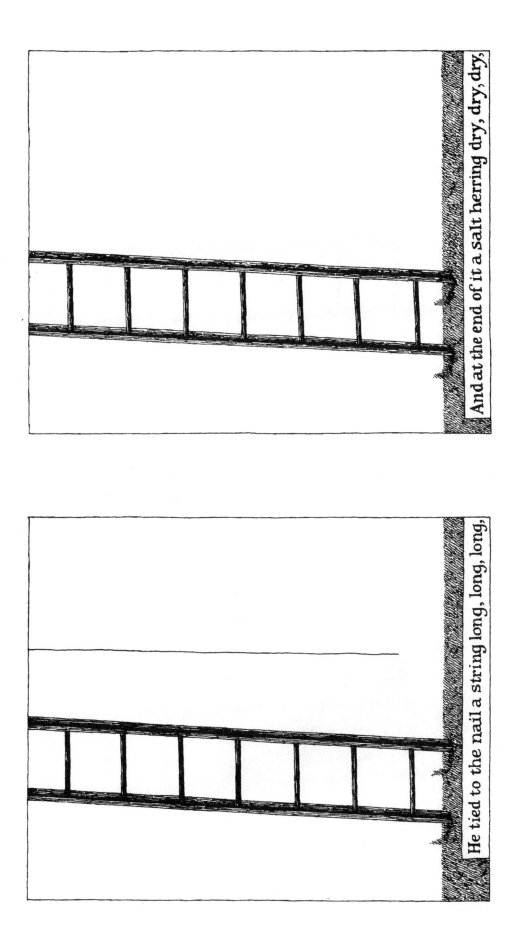

He tied to the nail a string long, long, long,

And at the end of it a salt herring dry, dry, dry,

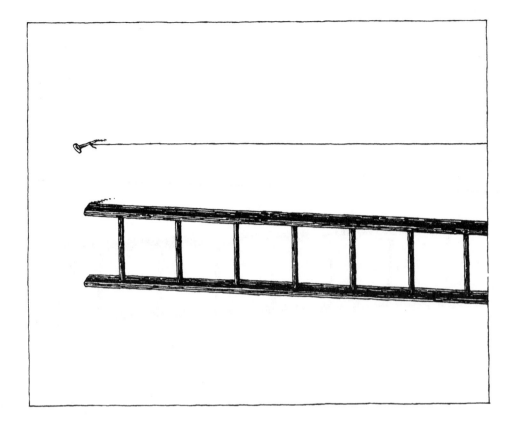

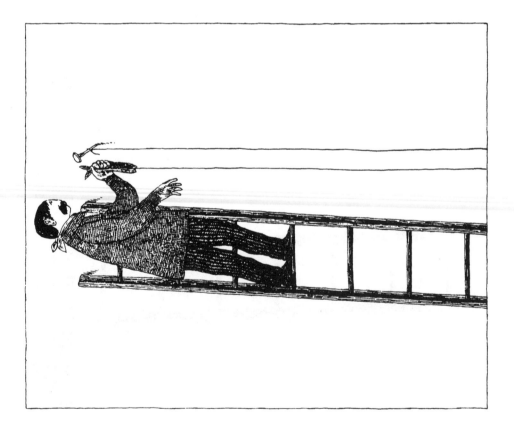

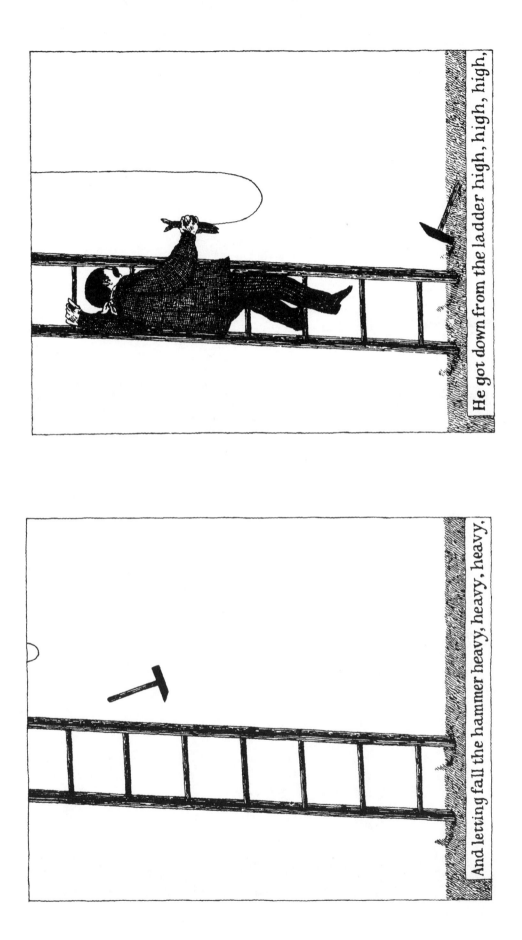

He got down from the ladder high, high, high,

And letting fall the hammer heavy, heavy, heavy.

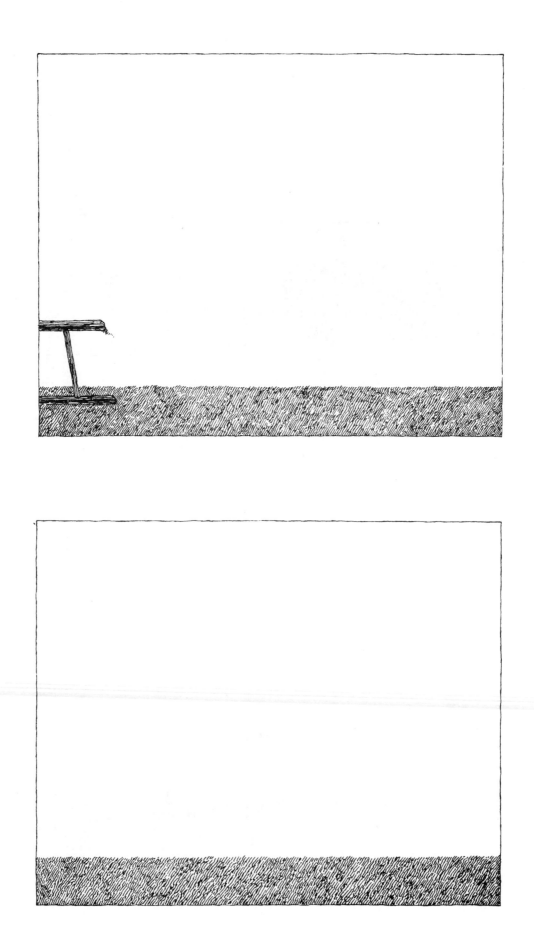

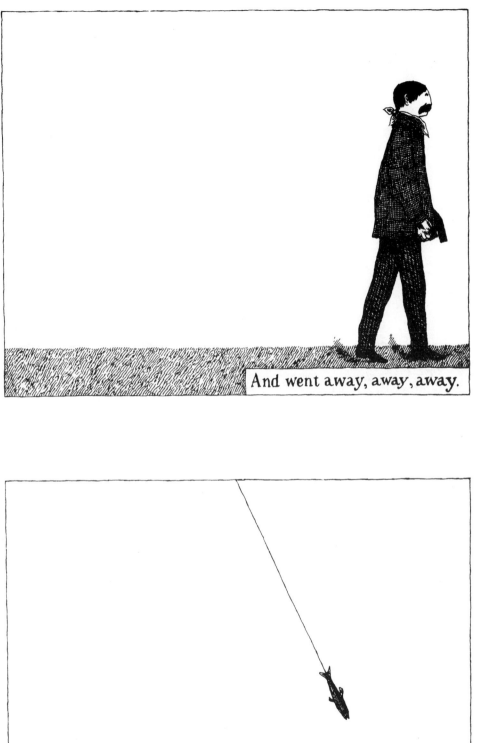

And went away, away, away.

Since then at the end of the string long, long, long,

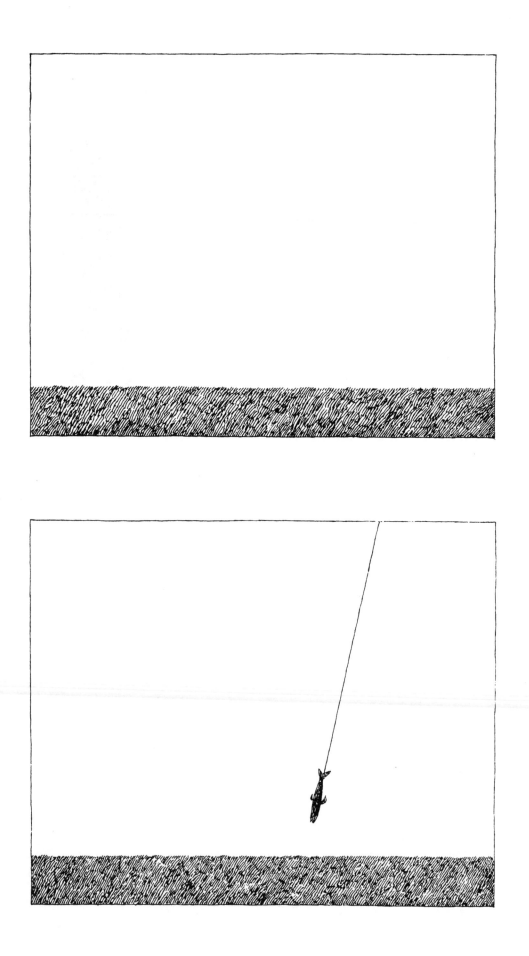

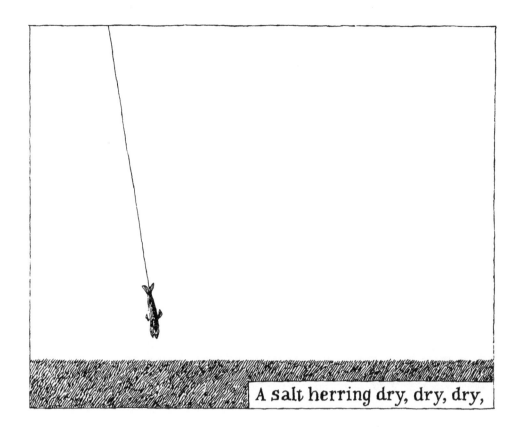

A salt herring dry, dry, dry,

Has been swinging slowly, slowly, slowly.

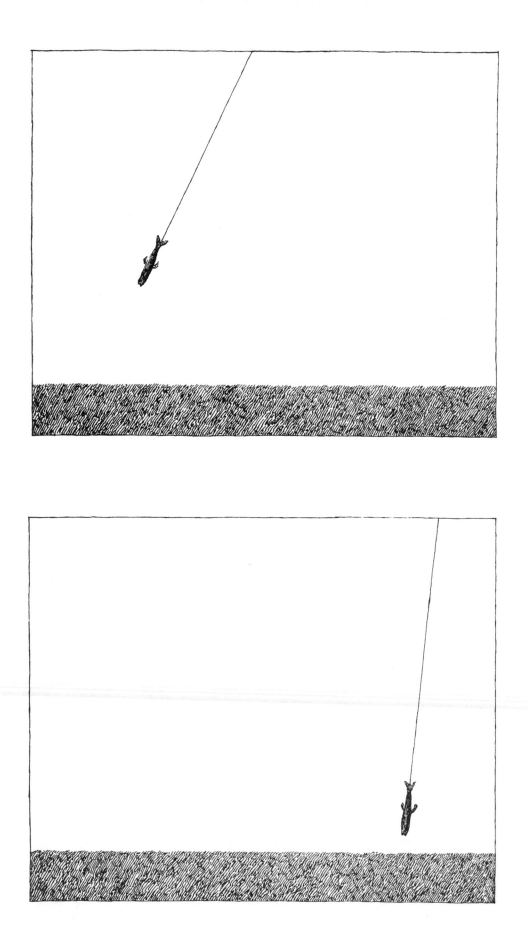

Now I have composed this story simple, simple, simple,

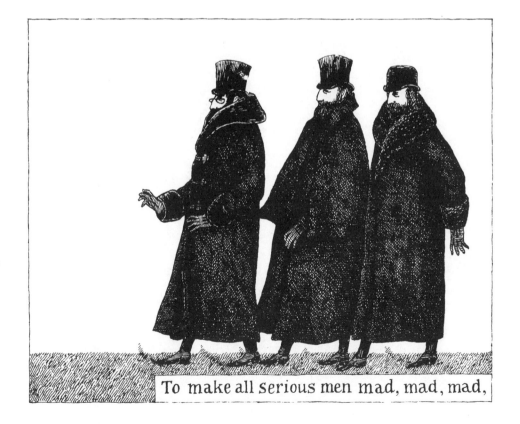

To make all serious men mad, mad, mad,

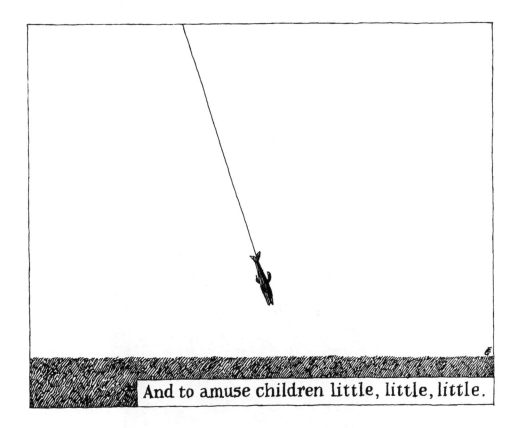

And to amuse children little, little, little.

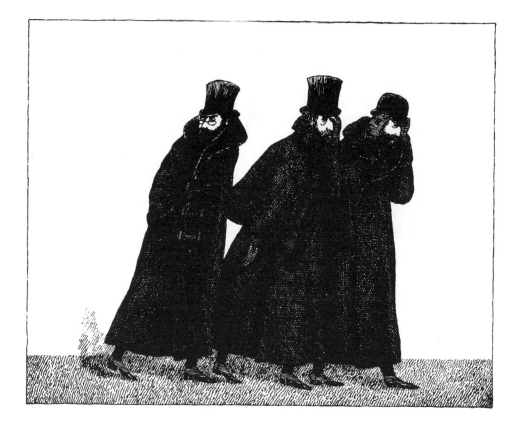

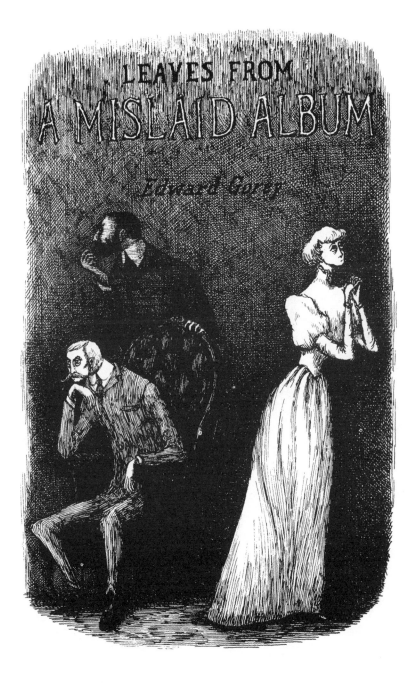

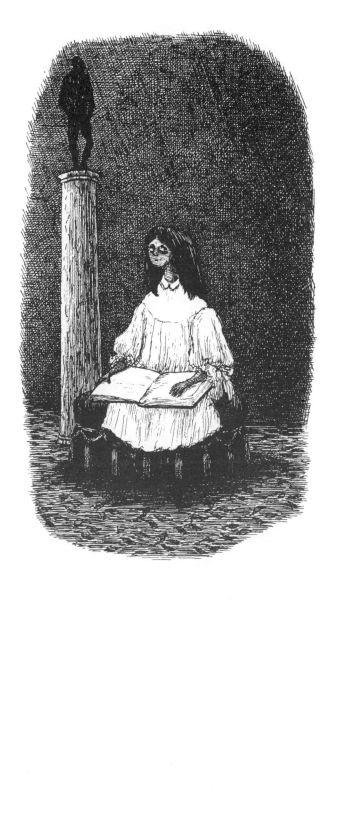

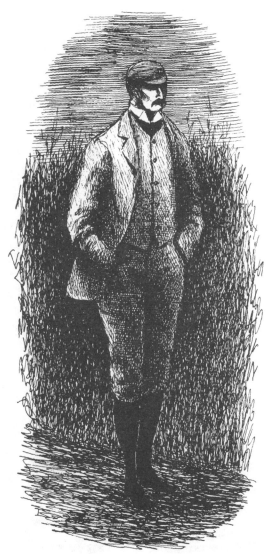

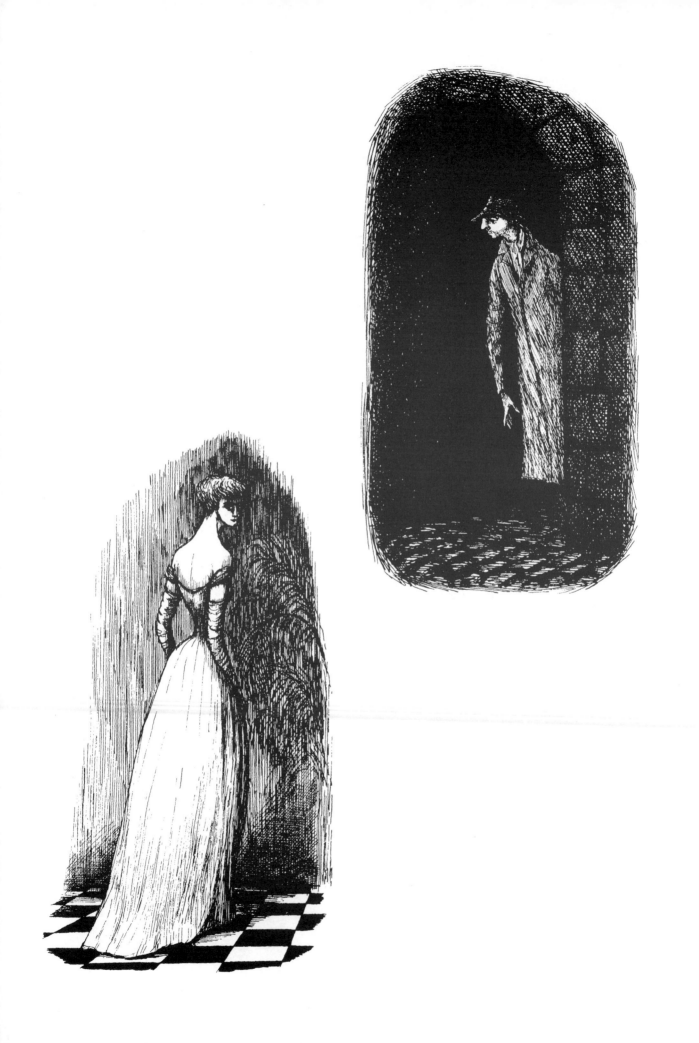

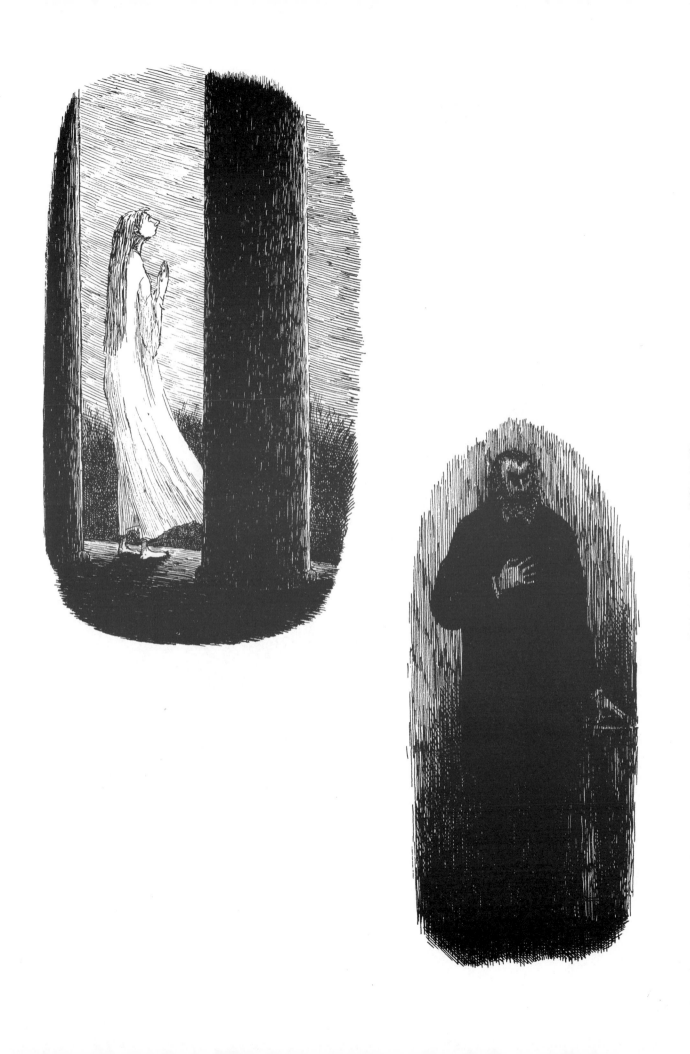

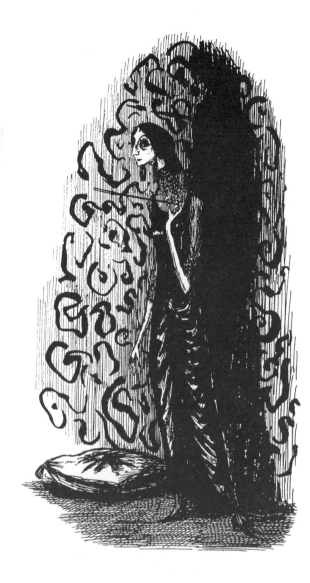

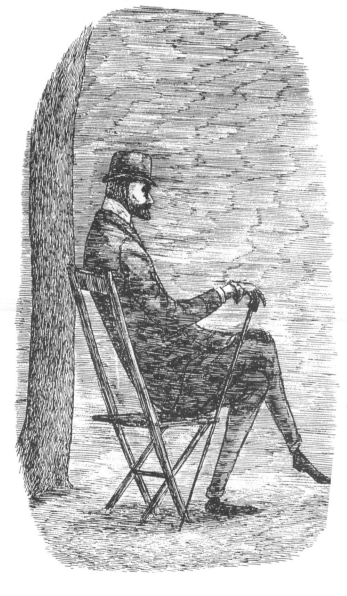

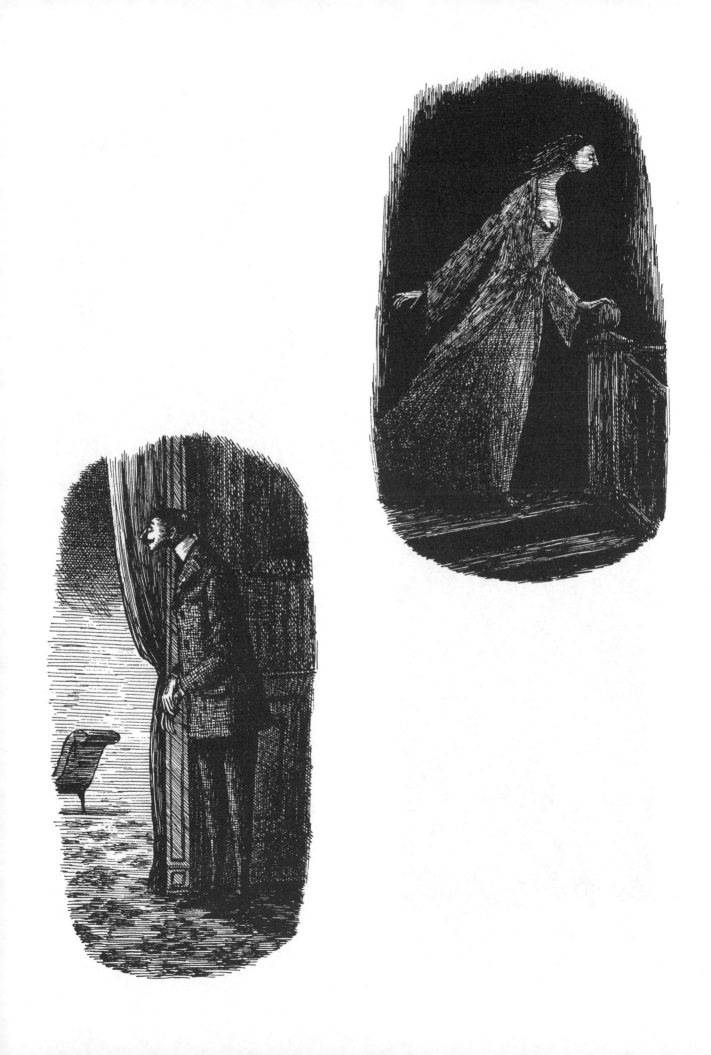

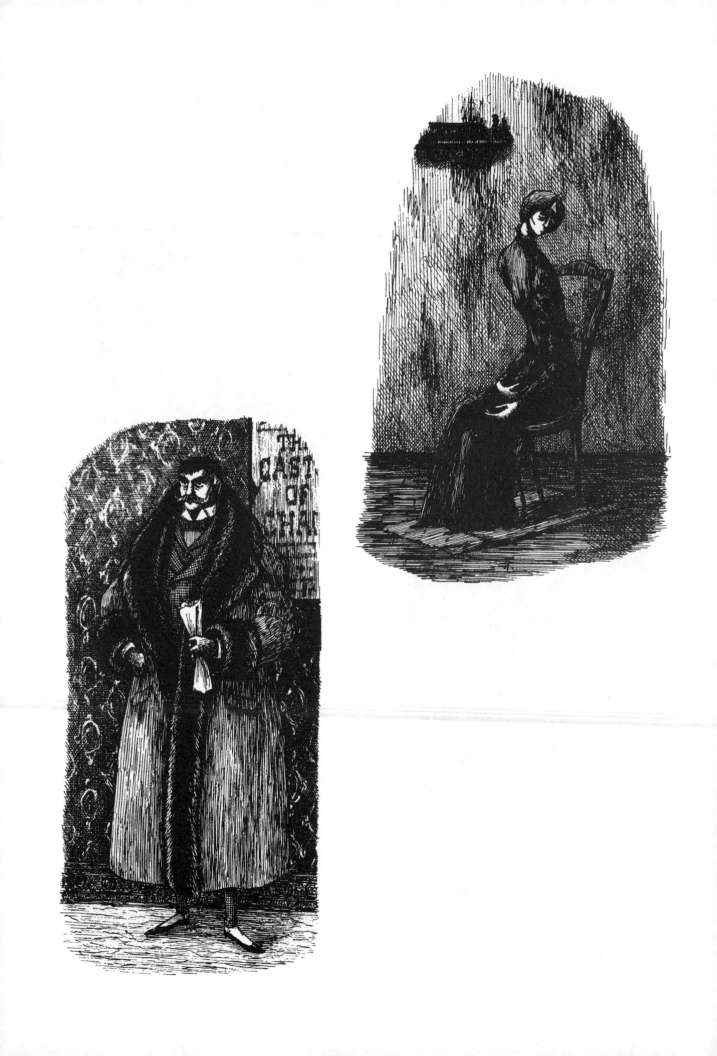

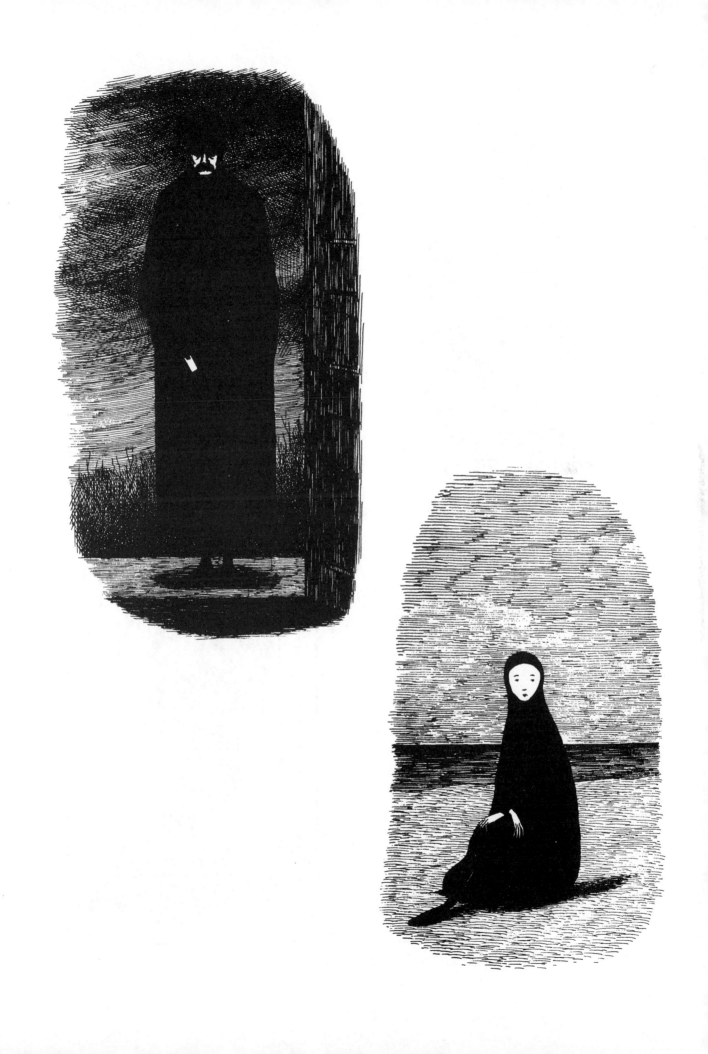

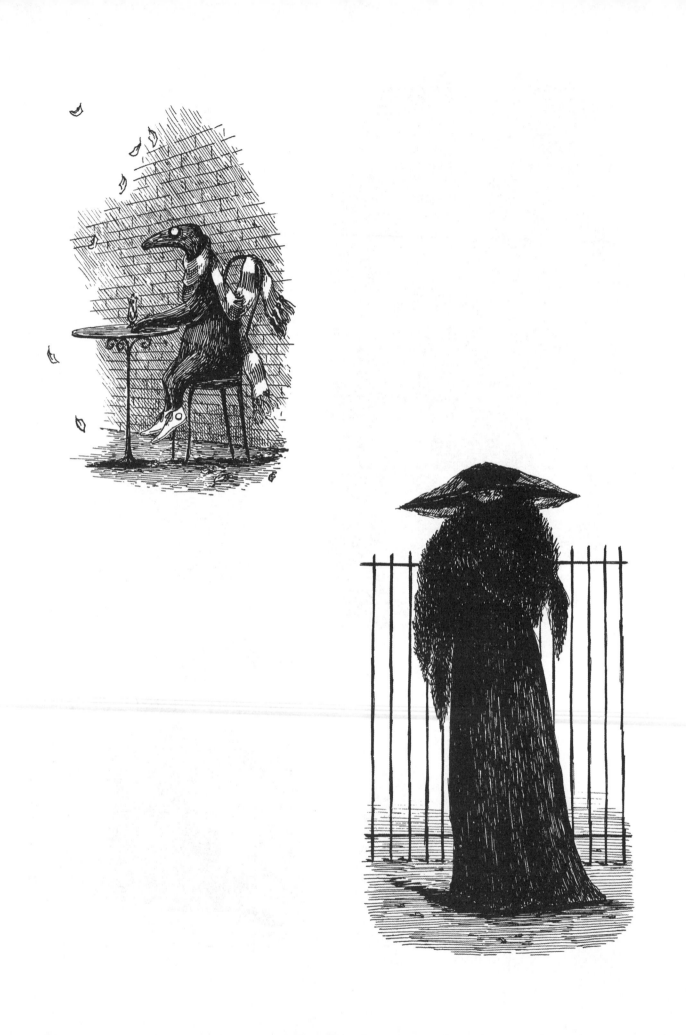

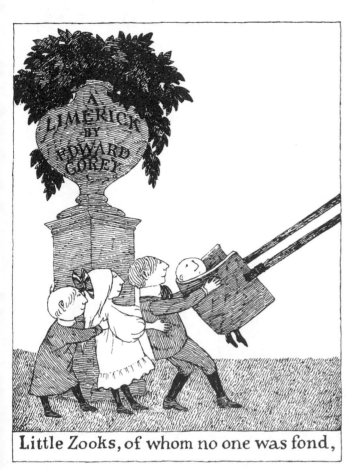

Little Zooks, of whom no one was fond,

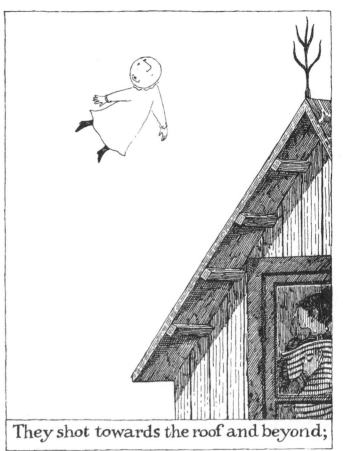

They shot towards the roof and beyond;

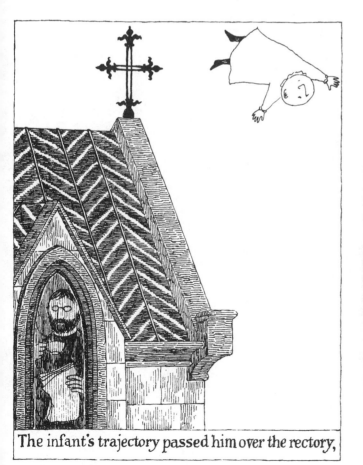

The infant's trajectory passed him over the rectory,

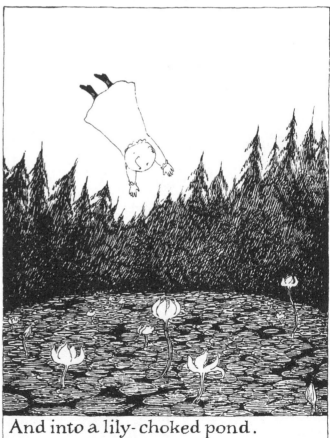

And into a lily-choked pond.

NOTE

The first version of *The Chinese Obelisks* has not been published before.
The English version of *Conte à Sara* is mine; that of *Le Hareng saur* is by Alphonse Allais.

E.G.